IMAGES
of America

SOCIETY HILL
AND OLD CITY

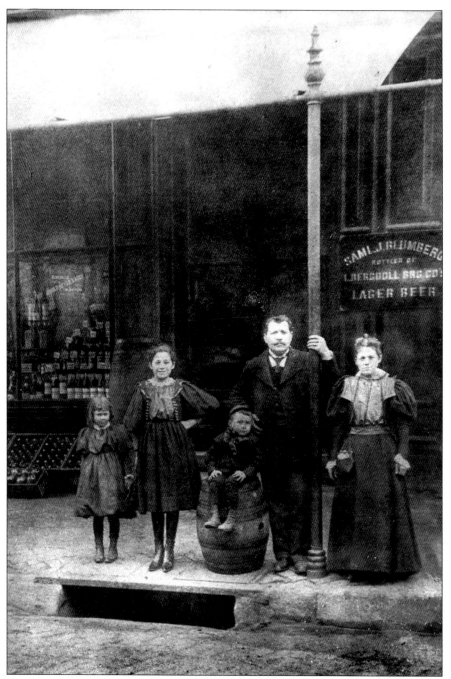

The Blumbergs pose in front of the family shop at the southwest corner of Sixth and Spruce Streets around 1898. Standing next to the pole is Samuel J., along with his wife, Rose. On the barrel is young Arnold, and standing on the sidewalk are his sisters. Arnold Blumberg would later become leader of the city's Fifth Ward and state assistant attorney general. The Blumbergs likely knew that their shop was a historic building. In 1896, friends of Joseph Jefferson, a famous comedian of the American stage, had placed a bronze plaque on the building noting Jefferson's birth there on February 20, 1829. (Courtesy Nancy Widerman.)

IMAGES
of America

SOCIETY HILL
AND OLD CITY

Robert Morris Skaler

Copyright © 2005 by Robert Morris Skaler
ISBN 0-7385-3818-3

Published by Arcadia Publishing
Charleston SC, Chicago IL, Portsmouth NH, San Francisco CA

Printed in Great Britain

Library of Congress Catalog Card Number: 2005922743

For all general information contact Arcadia Publishing at:
Telephone 843-853-2070
Fax 843-853-0044
E-mail sales@arcadiapublishing.com
For customer service and orders:
Toll-Free 1-888-313-2665

Visit us on the internet at http://www.arcadiapublishing.com

On the cover: This is Clinton Street. (Courtesy Charles Peterson Collection.)

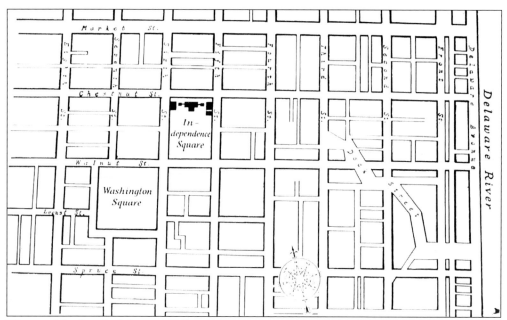

The neighborhood of Society Hill is shown on this map. The grid was laid out by William Penn's surveyor general, Thomas Holme, in 1683. One of the original five squares of his plan, the southeast quadrant, was named Washington Square in 1825. Snaking through Society Hill, Dock Street was built over Dock Creek, which had been covered for health reasons in the late 18th century. The area north of Chestnut Street is considered Old City.

Contents

Preface	6
Introduction	7
1. Society Hill	9
2. Delaware Avenue and Dock Street	55
3. Chestnut Street and Bank Row	65
4. Walnut Street and Insurance Row	93
5. Old City North of Chestnut Street	99
6. Society Returns to Society Hill	113
Acknowledgments	128

Preface

As a child in the late 1940s, I tagged along with my father to Dock Street to buy live chickens for the family meat market. I remember the scene as total chaos. In 1947, my parents took me to see the Better Philadelphia Exposition at Gimbel's department store. Designed by planner Edmund Bacon, it featured an enormous model of Center City that flipped over to show Society Hill and Penn Center in the future. It made such an impression on me that I decided then to be an architect. In the late 1950s, as a student of architecture at the University of Pennsylvania, I saw Bacon's proposal for Society Hill's redevelopment. Having once more been given a glimpse into the future, I tried to convinced my older brother Walter to buy one of the historic houses on Delancy Street. I said to him, "The dean of the school of architecture, who is also head of the city planning commission, just bought some houses on Lawrence Court. He must know something." At that time, many of Society Hill's houses where vacant and boarded up and could be purchased for about $6,000. After much coaxing, he agreed to take a walking tour of Delancy Street. As we looked around, a drunken sailor with a knapsack on his back staggered up the street. As he reached us, he suddenly threw up. That did it. "No one will ever want to live here!" my brother exclaimed. "You must be nuts!" Years later, I would purposely drive him down the same block, now fully restored and very expensive, to remind him of the lost opportunity.

One person who knew the historic value of those houses back in the 1950s, when few cared about their preservation, was Charles E. Peterson, architectural historian and longtime Society Hill resident. Peterson is credited with naming the neighborhood. Through scholarly research, he discovered that the Free Society of Traders, a defunct stock company organized in London in the 17th century to encourage settlement in Philadelphia, once owned the elevated land on which the neighborhood of Society Hill is situated. Peterson fought tirelessly to save the neighborhood's historic houses and structures from demolition. He photographed Society Hill in the late 1950s, leaving an invaluable record of the area before it became gentrified. A number of his photographs have been reproduced in this book.

INTRODUCTION

The neighborhood of Society Hill is bounded by the Delaware River to the east and Eighth Street to the west, and extends from Walnut Street south to Lombard. In the 18th century, this area was home to wealthy merchants who built elegant town houses. It was home to many members of the federal government when Philadelphia served as the nation's capital. Artisans and workmen also lived and worked here in small row houses or in bandbox houses on small courtyards like Drinker's Court or Loxley Court. Over the years, as a result of greed and speculation, the large lots of William Penn's "green country town" were divided and divided again. Colonial Society Hill included market stalls along South Second Street, churches of various denominations, a synagogue, numerous taverns and inns, Washington Square, and Pennsylvania Hospital.

By the mid-19th century, Society Hill had lost its cachet. Many of the old Quaker families, who by this time had become Episcopalians, moved west to Rhittenhouse Square, West Philadelphia, and beyond. In the 19th century, Philadelphia spread out in all directions. Unlike New York City, with a Colonial center bounded by two great rivers, Philadelphia developed and simply abandoned its Colonial center. Almost forgotten by 1900, the once gracious houses of Society Hill became shops, small factories, and tenements, and the neighborhood ultimately became tattered, with neighboring Dock Street becoming the city's food distribution center in the area of the Merchants' Exchange. In the early 20th century, Society Hill became home to Eastern European Jewish immigrants fleeing the pogroms of Poland and Czarist Russia. The "Jewish Quarter" was south of Spruce Street, centered on South Street from Second to Ninth Streets. As the demographics of the neighborhood changed, so did some of its religious institutions. In 1908, the Spruce Street Baptist Church was abandoned by its congregation, who moved further west. Three years later, it became a synagogue, and still is today.

In the late 1950s, a master plan for the renewal of Society Hill was made by city planner Edmund Bacon. A new food distribution center was built in South Philadelphia, allowing the demolition of the deteriorated Dock Street area, which was a great source of traffic congestion and unsanitary conditions. On the site was built the Society Hill Towers, designed by architect I. M. Pei, who won the competition for their design. According to Bacon, the tall towers were meant to be a symbol of the newly emerging Society Hill. However, to some, Society Hill Towers seem out of scale with their surroundings, hovering like Godzilla over the neighborhood.

What makes Society Hill's restoration unique is that vacant historic Colonial houses were acquired by the Philadelphia Redevelopment Authority and sold to private citizens, along with a binding agreement that the individuals restore the buildings to meet the historic-restoration standards. In this way, approximately 600 historic houses were renovated. Following the lead of Philadelphia's mayor from 1956 to 1962, Richardson Dilworth, who built a new Colonial-style home on Washington Square in 1957, other prominent Philadelphians like C. Jared Ingersol and Dr. F. Otto Haas acquired and restored homes in Society Hill. The renewal took off. Empty

lots were soon rebuilt with contemporary brick houses that complemented the existing historic houses in the area. Society Hill, once Philadelphia's "has-been neighborhood," is today one of the city's most prestigious and pedestrian friendly, with an active civic association representing 5,000 residents.

However, the splendid rebirth of Society Hill and parts of Old City has had a downside. For in its fervor to recreate a Colonial park-like atmosphere in Independence National Historical Park, the city of Philadelphia declared Society Hill and Old City legally "blighted" areas. This allowed the city and the National Park Service to demolish some of Philadelphia's finest Victorian structures on Bank and Insurance Rows, including the oldest cast-iron building in the country and many of architect Frank Furness's best works. Perhaps the "colonialists" were unconsciously getting even for Furness's Penn National Bank, which was built on the site of the historic Graff House, where Thomas Jefferson penned the Declaration of Independence. The end result of all this demolition is a charming but somewhat sterile setting. In addition, not all of Edmund Bacon's planning ideas "sizzled." An endless number of small buildings, many historical, were razed because the designation of what was historical was so arbitrary. Bacon's concept for Market Street East turns its back on Market Street and does not connect historic Old City with the rest of the street. The cross-town expressway, which was fortunately stopped by public outcry, would have been a disaster if built. Most of the originally proposed landscaped cover for the depressed Interstate 95 was never built, and is not the fault of Edmund Bacon, whose design for Penn's Landing has still not been realized after 50 years, mostly due to the ineptness and byzantine politics of successive city administrations.

Despite all of the aforesaid planning setbacks, if one considers that Society Hill could have been demolished for a 1960s slum-clearance project similar to Southwark Plaza on Washington Avenue—which became a crime-ridden high-rise slum and was eventually destroyed—future generations of Philadelphians should be ever indebted to Edmund Bacon, who as of this writing is 92 years old, for promoting the area's restoration and gentrification.

Regrettably, for space reasons, not every historically significant church and important building could be included in this book. Selected images of restored and demolished 18th- and 19th-century structures are shown in the book and their architects are named whenever possible. It is the author's hope that the reader will use this book as a walking guide to examine how much these two historic neighborhoods have both changed and remained the same in the last 200 years.

—Robert Morris Skaler

One
SOCIETY HILL

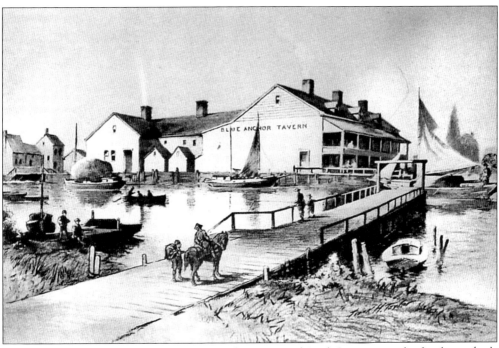

The Blue Anchor Inn, located near present-day Front and Dock Streets, was the first house built in Philadelphia, and here William Penn landed upon his arrival in the city. The drawbridge shown on the right crossed Dock Creek, which flowed from the northwest into a tidewater snug harbor. Philadelphia's commercial center started here and grew around the creek. By 1784, Dock Creek had become so polluted that it was covered over and paved, becoming Dock Street. In the mid-19th century, the area to the southwest of Dock Street changed, as houses were converted into small warehouses, sweatshops, and factories. To the west, Society Hill developed as a residential neighborhood. By 1870, the Dock Street area had become the city's wholesale meat and produce center because of its access to both arriving ships and the railroad.

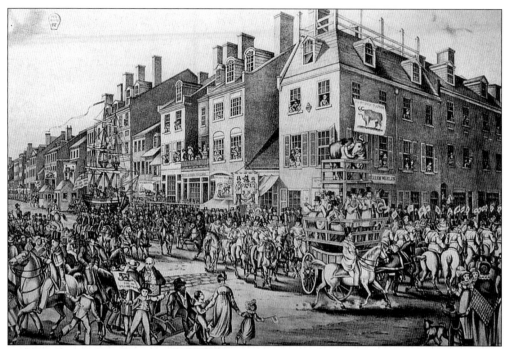

Published in *Moses King's Notable Philadelphians* of 1902, this famous engraving is titled *Whites Great Cattle Show, Procession of the Victuallers of Philadelphia, March 15, 1821*. William White's convoy of exhibition cattle are displayed in carts heading east on Chestnut Street and rounding the corner of Fourth Street toward Market. This provides a glimpse of Society Hill when it was the center of commerce in Colonial Philadelphia.

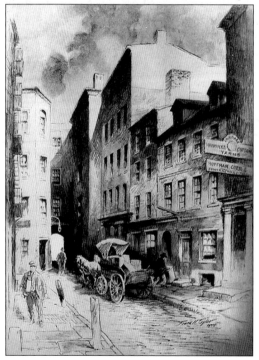

Between Third and Fourth Streets, accessible only from Chestnut Street, was South Orianna Street. There stood Benjamin Franklin's house, called Franklin's Court, where he completed his autobiography and subsequently died. Artist Frank H. Taylor's drawing shows the court in 1900. In 1950, the National Park Service uncovered the foundations of Franklin's 1792 house, now displayed in an underground museum.

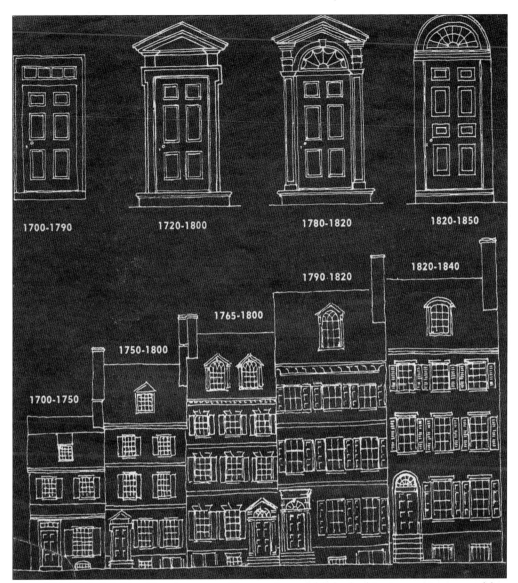

The Old Philadelphia Development Corporation published this instructive pamphlet, written by Arnold Nicholson and illustrated by Penelope Hartshorne, to aid new Society Hill homeowners in identifying the age of their house by its exterior architectural detail. The oldest houses were the smallest, usually built with a gambrel roof. The heavy cornices and bold ornamentation of Colonial times began to change shortly before 1800. With the Federal Period, houses were built bigger and designed with lighter, more delicate architectural details. The window areas were enlarged, as shown in houses erected between 1790 and 1820. Philadelphia's row-house version of Greek Revival style can be seen in the arched doorway and rounded roof dormers of that period. Doorways offered Colonial builders the opportunity for ornamental design and detail that exhibited the owner's wealth and status to passersby. (Courtesy Penelope Hartshorne Batcheler.)

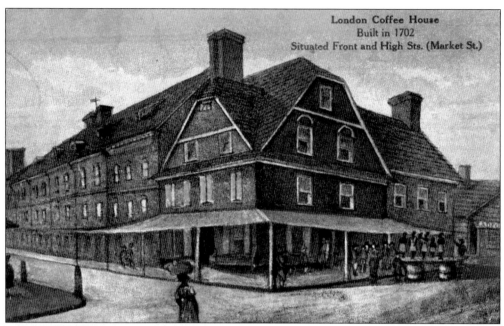

Built in 1702, the Old London Coffee House was a convenient place for the informal exchange of commerce and politics. Communications with New York through stagecoaches, wagons, and boats arriving at the port made it an ideal location. This 1907 postcard based on an 18th-century painting shows the building, which once stood at Front and High (Market) Streets. Surprisingly, the painting also shows slaves being sold at auction on High Street.

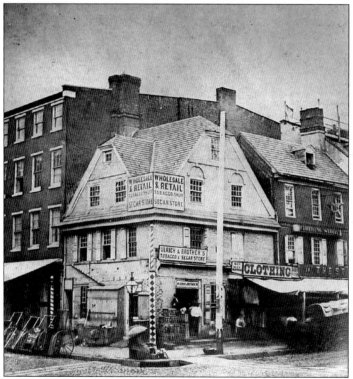

This c. 1854 photograph shows the Old London Coffee House after it had gone through many changes and owners. Until demolition in 1883, the building was owned by the Ulrich & Brother's purveyor of "Tobacco & Segars," whose family had owned it for many years. (Courtesy Independence National Historical Park.)

This photograph, taken around 1860, shows the southeast corner at Second and Delancy Streets. By the mid-19th century, many 18th-century Colonial houses were already being used for commercial purposes. The gambrel roof of the corner house indicates that it was built prior to 1750. (Courtesy Independence National Historical Park.)

At 332 Delancy stood the home of carpenter Jonathan Evans, a leading Quaker of his time. He refused to fight in the Revolution and therefore was sent to prison for 16 weeks. Evans built his house about 1785, at the time of his marriage to Hannah Bacon. This photograph was taken in 1912. The Evans house still stands, although a new house was constructed on the side yard.

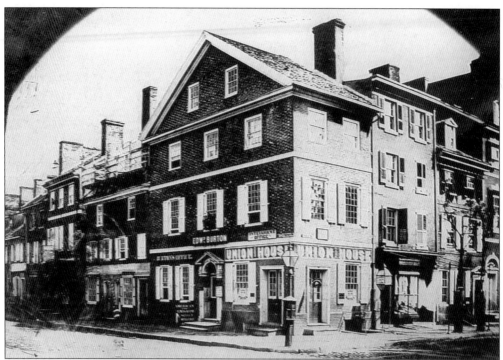

This c. 1857 photograph of the southeast corner at Third and Spruce Streets is from the collection of Dr. W. R. Duntun. Judging from its design, the corner house was likely built around 1760. It later became a commercial property. The wooden slats on the roof of the adjacent house were used for stringing laundry lines. The variety of sizes, styles, and ages of the residences on the block gives Society Hill its unique character in the 21st century. (Courtesy Independence National Historical Park.)

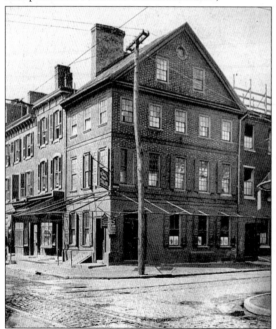

This 1912 view at Fourth and Spruce Streets shows an 18th-century house now used as a tailor's shop. Most of the houses on that block were converted to stores in the late 1860s. The corner house's design is typical of corner houses of the period, and can be seen in many 18th-century and reconstructed houses in Society Hill.

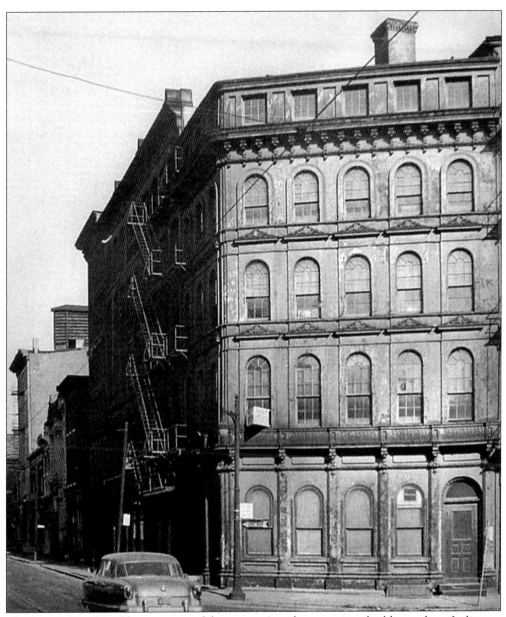

The Penn Mutual Building was one of the country's earliest cast-iron buildings whose Italianate façade was made by bolting together cast-iron plates. Once located at the northeast corner of Third and Dock Streets, the structure was designed by architect C. P. Cummings and built in 1850 by Joseph Singerly, who was paid 6.25¢ per pound. The building was unfortunately demolished in 1956 as part of the Dock Street area's redevelopment. A statue of William Penn that was removed from the structure before its demolition can be seen in the lobby of the present Penn Mutual Building at Sixth and Walnut Streets.

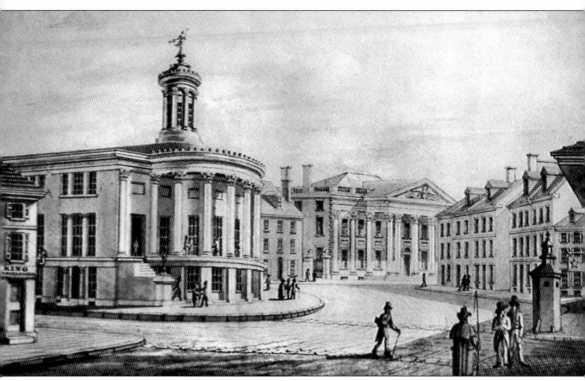

In 1831, Philadelphia's social and business elite organized a society to build a stock exchange. Included in the group was Stephen Girard, the wealthiest man in the nation. The directors decided on architect William Strickland, known to favor the Greek Revival style. Strickland made this drawing of the exchange building at Dock Street. The Girard Bank building is in the background. The exchange's cornerstone was laid on the 100th anniversary of Washington's birth, in 1832. It is said that more than one million bricks were used in the construction. The arrival of merchant ships could be seen from the exchange's tower, whose design Strickland adapted from the choragic monument of Lysicrates in Athens. The semicircular portico, Strickland's design solution to an odd-shaped lot bounded by Walnut, Third, and Dock Streets, makes the architecture of the Philadelphia Merchants' Exchange unique. Its image can be found on a 15¢ U.S. postage stamp issued in 1979.

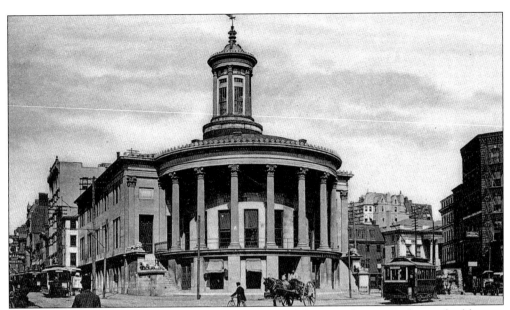

The c. 1900 postcard view above shows the Philadelphia Merchants' Exchange building in its final days as a stock exchange. Below, the exchange is seen in 1926, at the time of the sesquicentennial celebration in Philadelphia. The exchange had been sold to a firm that made it a produce exchange in 1922. Like the nearby Dock Street market, an open-air market with tin sheds surrounded the building, and vendors hawked vegetables from pushcarts. The exchange's curved portico follows the line of Dock Street, which was built over the old Dock Creek, a tributary of the Delaware River that once snaked through Society Hill. A gas station was later built on the building's Dock Street side. In 1952, the Independence National Historical Park bought the deteriorated structure and restored it.

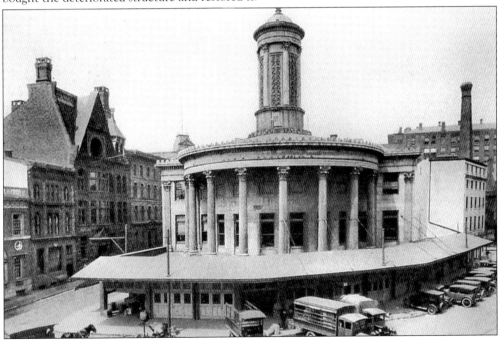

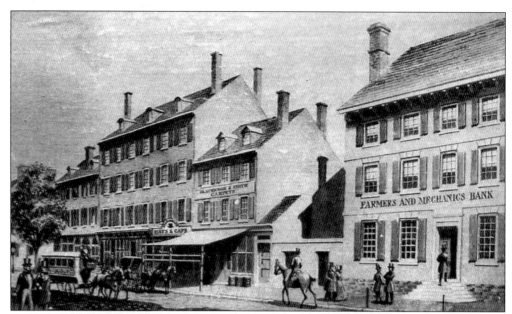

Artist Henry B. McIntire's sketch portrays the north side of Chestnut Street between Fourth and Fifth Streets in the 1850s. By the mid-19th century, Chestnut was already beginning to have banks and commercial establishments in structures originally built as homes. In 1855, the Farmers and Mechanics Bank built a new building on the same site that is still in use today. (Courtesy Independence National Historical Park.)

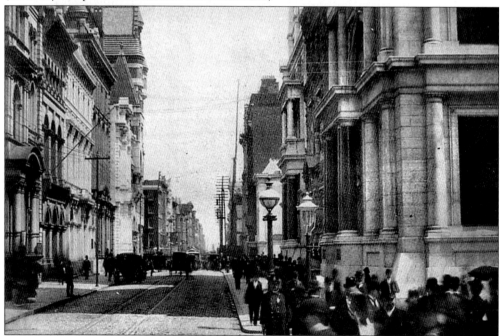

This 1899 view reveals Chestnut Street, looking east from Fifth. On the north side of the street was Bank Row, which included the Farmers and Mechanics Bank. Philadelphia was now a modern commercial city, with lower Chestnut as its financial hub. The large building in the foreground was the headquarters of Drexel and Company.

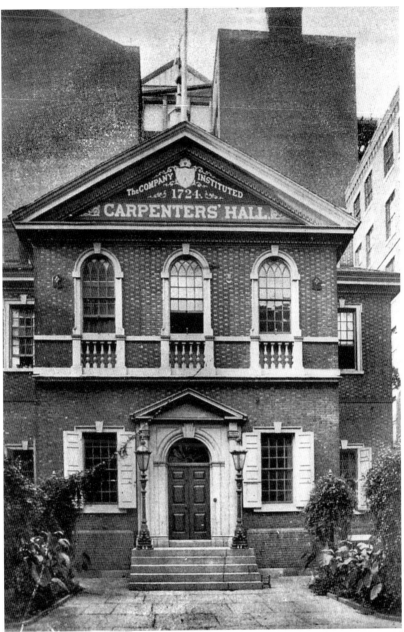

Carpenters' Hall was designed by architect Robert Smith in 1770–1774 in a cruciform plan as if it was to be a freestanding building. In the fall of 1774, Carpenters' Hall was chosen as a meeting place by delegates to the First Continental Congress, who convened in the first-floor room, which at the time was the largest meeting room in Colonial Philadelphia. The country's founding fathers all met within its walls, including Benjamin Franklin, George Washington, Patrick Henry, Alexander Hamilton, and John and Samuel Adams. This 1905 image shows how Carpenters' Hall was closely surrounded by large Victorian buildings. In 1955, the National Park Service demolished all non-Colonial structures on the block to protect Carpenters' Hall from fire, thus making the building's freestanding design visible. The park service also reconstructed the Pemberton House on Chestnut Street, next to the hall's gated entrance.

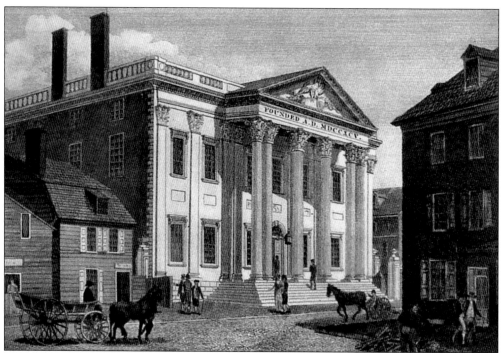

Above, a *c.* 1800 William Birch print depicts the oldest bank building in the country, which was designed by architect Samuel Blogett Jr. in 1795. Its neoclassical design was intended to recall the democracy and splendor of ancient Greece. Located at 120 South Third Street, it was the First Bank of the United States until its charter lapsed in 1811. Stephen Girard, the nation's richest man, bought the building in 1812 and made it his private bank. The building was used by the Girard National Bank from 1832 (the year Stephen Girard died) until 1926. Below is a retouched postcard of the bank's façade, showing the pediment with the eagle and shield by sculptor Cladius LeGrand. The building was restored by the National Park Service in 1974–1976 and again in 2005. It is now a museum.

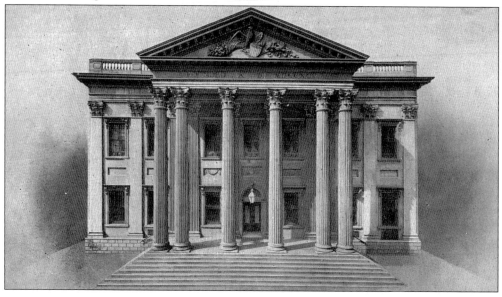

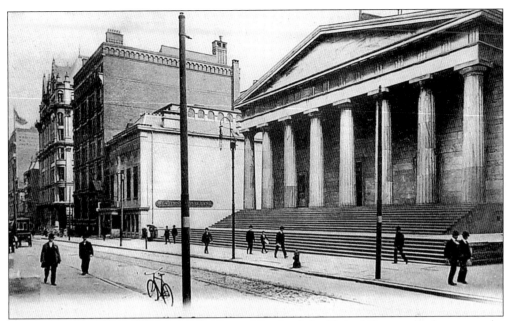

Located at 420 Chestnut Street is the Second Bank of the United States, also known as the Old Customs House. The Chestnut Street façade of the building is shown in the above c. 1905 postcard view, looking east. Architect William Strickland, who also designed the classically inspired Philadelphia Merchants' Exchange, won a competition for the bank's design in 1818. Strickland based his design loosely on the Parthenon in Athens. The design was greatly acclaimed, establishing the popularity of Greek Revival style not only in the Philadelphia, but also elsewhere in the country. This classical style gained great popularity in the southern states, where it became favored for plantation houses after Strickland designed Tennessee's classical state capitol in Nashville. The below c. 1940 postcard shows the bank's Samson Street façade. In the background is the Drexel Building, which was demolished in the 1950s. (Courtesy Howard Watson.)

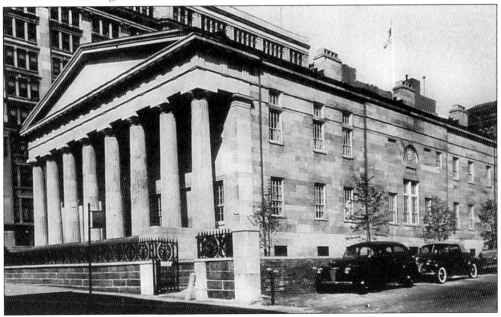

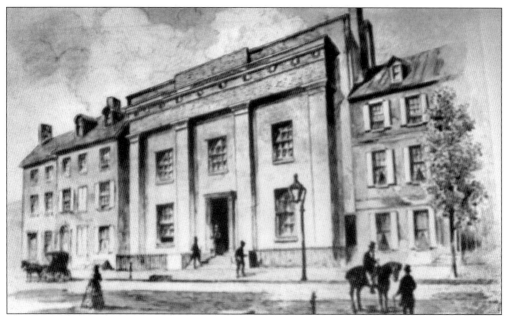

Originally the home of the Franklin Institute, the Atwater Kent Museum was built around 1827, looking then like the above historical sketch by Frank Taylor. Located at 15 South Seventh Street, it was designed in a Greek Revival style by architect John Haviland, who gave this small building a monumental classical façade. The same classical façade can be seen on the Federal Reserve Bank at Tenth and Chestnut, designed by architect Paul P. Cret in 1932. With the help of Samuel V. Merrick, the Franklin Institute was founded in 1824 and soon became a major influence in promoting American industry and encouraging inventors by annually awarding industrial achievement medals. As well as promoting scientific research, the Franklin Institute offered instruction in architecture and drafting. The below 1920 photograph shows the building sandwiched between two commercial structures. In 1939, it became the Atwater Kent Museum.

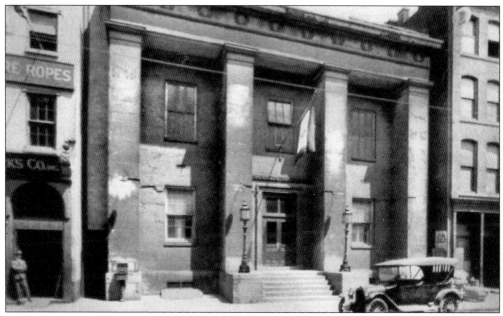

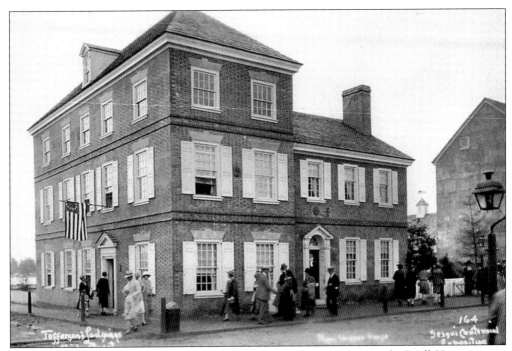

Philadelphia's sesquicentennial exposition built a replica of the Jacob Graff House on its South Philadelphia exposition grounds. In 1776, Thomas Jefferson wrote the Declaration of Independence in the original Graff House, which stood at Seventh and Market Streets. By 1863, the house was a print shop before being demolished in 1883. Ironically, Society Hill was so shabby in 1926 that the exposition chose to construct replicas of historic houses at South Broad Street rather than restore the original structures.

Penn National Bank acquired and then demolished the Graff House in 1882, and hired architects Furness and Evans to design a new structure. In the 1930s, this new bank building was torn down. In the 1950s, a one-story Tom Thumb hotdog stand stood on the site, with a large Stern's department store billboard looming overhead, painted on the wall of the adjacent property. In 1975, the National Park Service reconstructed the Graff House.

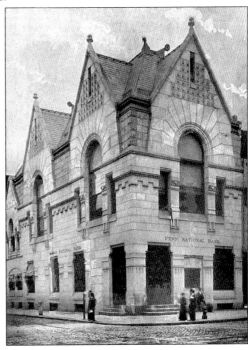

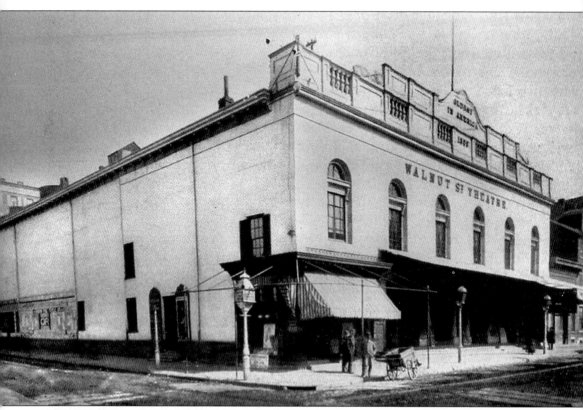

The Old Walnut Street Theater stands at the northeast corner of Ninth and Walnut Streets. Built in 1807, it is the oldest existing theater in the country. The present Greek Revival façade is based on an 1828 design by architect John Haviland, which is seen in this c. 1855 photograph. The theater has been renovated and enlarged numerous times. Legends such as Edwin Forest, John Drew, Edwin Booth, Fanny Kemble, the Barrymores, and George M. Cohan have walked its stage. The Walnut Street Theater has had a checkered history; it was a vaudeville house in 1900, a burlesque house in 1930, a WPA theater project in 1934, and later a stage for Yiddish dramas. The structure was designated a National Historical Landmark in 1968. Today, it is the largest subscription theater in Philadelphia.

John Reynolds's Georgian town house, located at 225 South Eighth Street, is shown at right about 1900, when it was flanked by houses on both sides. The Reynolds Morris House, as it is known today, was built in 1786, when Philadelphia was going through a postwar building boom. In 1817, Reynolds sold the house to Luke Wistar Morris. The below c. 1917 photograph shows the house, which was then occupied by Effingham B. Morris. It had been returned to its 18th-century appearance with side gardens, the adjoining houses having been demolished. The house and its gardens were lovingly maintained for over 100 years by the Morris family as a private residence, even as the surrounding area deteriorated.

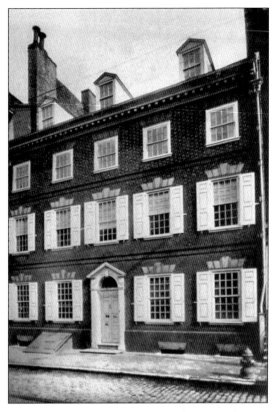

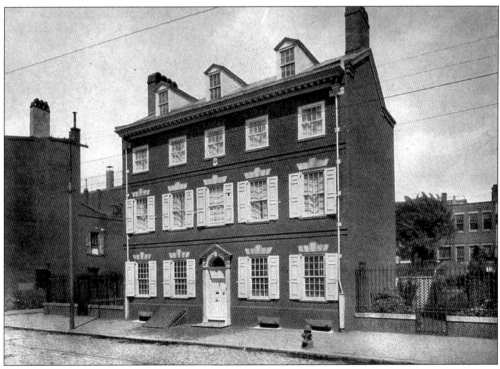

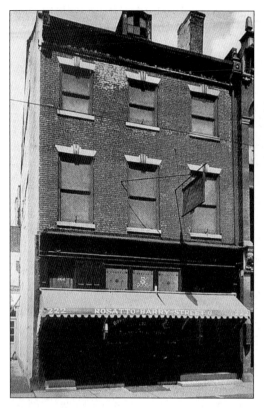

Amos Bronson Alcott, who was identified with the transcendentalist movement in New England, opened a school at 222 South Eighth Street in 1830. The building appears here in 1939, when it was photographed by historian and author Joseph Jackson. In 1831, Alcott moved his school to 5425 Germantown Avenue, where his daughter Louisa May, the renowned author of *Little Women*, was born in 1832.

The house at 715 Spruce Street was built in 1821 by Whitton Evans, one of Philadelphia's richest India merchants, who also kept an elephant in his backyard. In 1823, he sold the house to banker Nicholas Biddle, promoter of the Greek Revival design for Girard College's Founders Hall. This 1939 photograph shows the house when it was owned by the American Catholic Historical Society. It has since been restored by its present owner, Dr. Robert J. Gill.

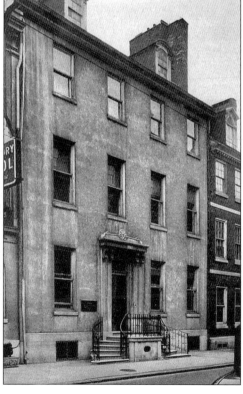

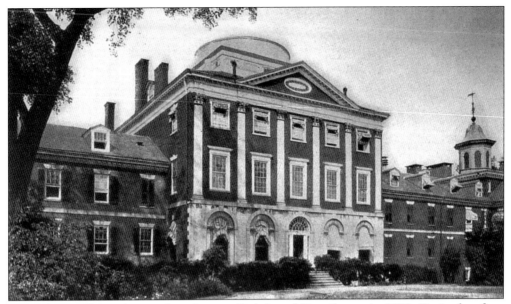

Pennsylvania Hospital opened its doors at Eighth and Pine Streets in 1756. On its first floor were rooms for mentally handicapped patients, making the facility a pioneer in the treatment of mental illness. The hospital's east wing was designed in an American Adamesque style by architect Samuel Rhoads. The west wing was built in 1796 and the center house in 1805, designed by David Evans Jr., who fit together all the additions into a perfect ensemble.

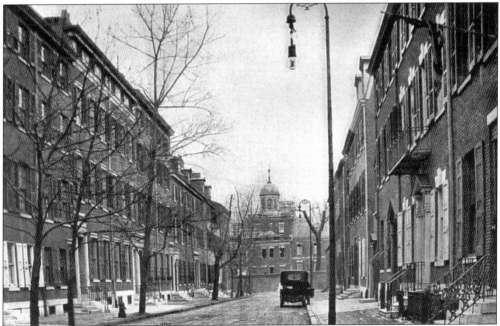

Named for DeWitt Clinton, builder of the Erie Canal, Clinton Street looks much the same today as it did in this c. 1919 view, looking east toward Pennsylvania Hospital and Ninth Street. When the street opened in 1836, wealthy families moved here to escape the hurly-burly of the city. The houses were spacious, built in a dignified and respectable Federal style in keeping with the Quaker city's traditions.

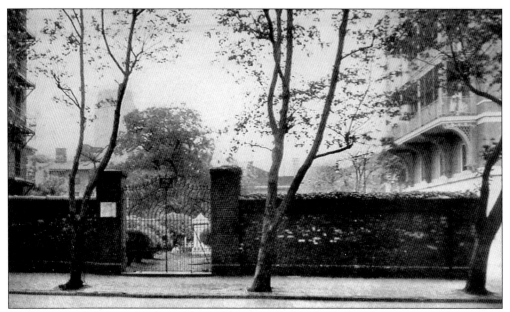

At Darien and Spruce Streets is the red-brick-walled Mikveh Israel Cemetery, whose gated entrance is seen here. Dating from 1740, the cemetery was the burial ground for Sephardic Jews who originally came with the Dutch to Philadelphia. It was in 1740 that the first part of the present Spruce Street location was purchased from William Penn's son Gov. Thomas Penn by Rabbi Nathan Levy. Additional land for the cemetery was later purchased from John Penn, Thomas Penn's nephew.

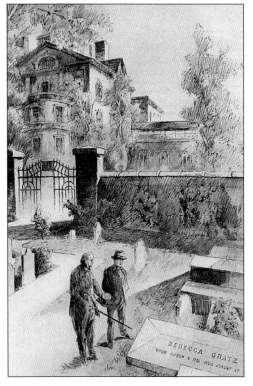

Buried in Mikveh Israel Cemetery are Haym Salomon, who helped the colonies by financing the Revolution, and Rebecca Gratz, who devoted her life to charitable causes and served as the inspiration for the character Rebecca in Sir Walter Scott's novel *Ivanhoe*. Also interred in the cemetery are Jewish soldiers who served in the Revolutionary War and the War of 1812.

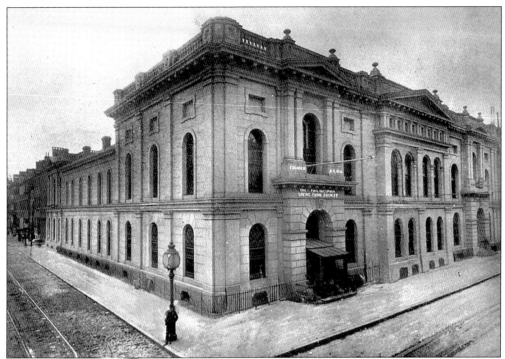

The Philadelphia Saving Fund Society was located at 700 Walnut Street. The building, seen here in a c. 1898 photograph, was previously added to many times but always in keeping with architect Addison Hutton's original 1869 design. The bank was later known as PSFS. In 1930, in the midst of the Depression, while other banks were failing, its directors decided to construct the country's "Building of the Century": the PSFS Building.

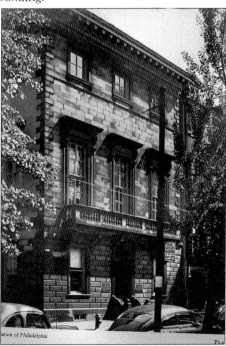

On the east side of Washington Square stands the Athenaeum of Philadelphia, which is still very active today. Built in 1847 in the Italianate style by architect John Notman, the building's coursed brownstone façade influenced 19th-century Philadelphia architecture. As Society Hill deteriorated over time, the Athenaeum chose to remain on Washington Square rather than relocate.

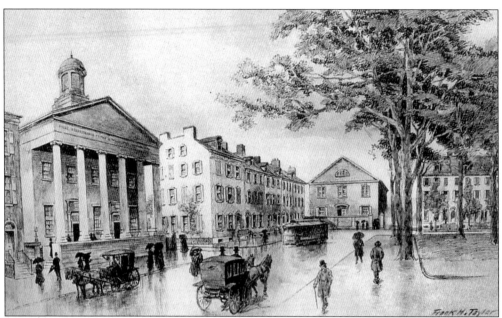

Washington Square, one of the five original public squares laid out for William Penn by Thomas Holm, was once Philadelphia's potter's field. Buried here are hundreds of Continental soldiers and thousand of victims of the yellow fever epidemic that ravaged the city in 1793. In 1825, the square was leveled and made into a memorial park. The above *c.* 1900 drawing by Frank H. Taylor shows the southwest side of the square and the Greek Revival–style First Presbyterian Church, which was designed by John Haviland and built in 1820. By the 1930s, the congregation had moved to West Philadelphia and their former church had fallen into disrepair. In 1962, the high-rise Hopkinson House was constructed on the church site. At the southwest corner of the square was the Orange Street Quaker Meeting House. Several of the town houses shown in Taylor's drawing still stand today, as seen below.

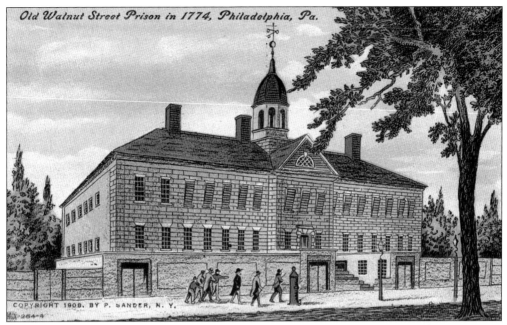

The Walnut Street Prison, designed by architect Robert Smith, was built in 1775 on the south side of Walnut Street, between Fifth and Sixth Streets. After the Revolution, a prison reform movement in which redemption was made part of imprisonment converted the notorious jail into a penitentiary. Many came to study what was considered then humanitarian treatment of prisoners. With the opening of two new prisons in Philadelphia, this building was demolished in 1835.

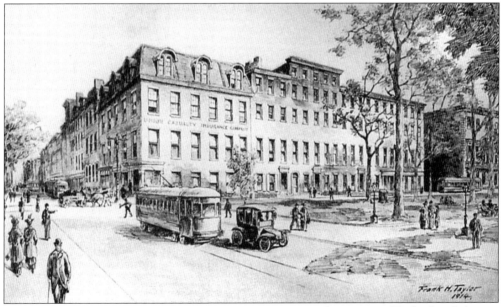

Built on the site of the Walnut Street Prison in 1837 was an elegant row of Federal-style houses facing East Washington Square. The homes were eventually converted into law offices and became known as Lawyers' Row. This sketch by Frank H. Taylor shows the southeast corner of Sixth and Walnut Streets as it looked in 1913, just before Lawyers' Row was demolished to make way for the Penn Mutual Life Insurance Company.

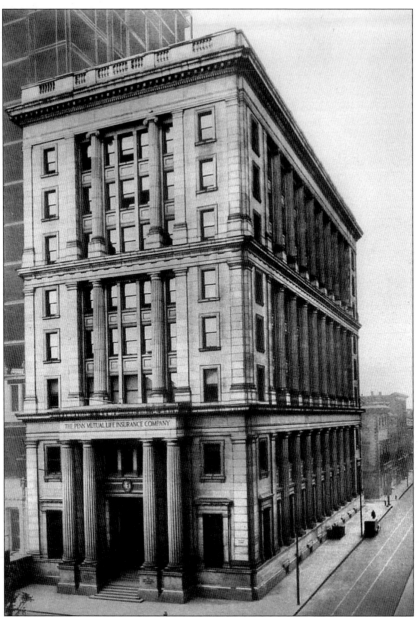

This 1930 photograph shows the original Penn Mutual Insurance Company building, as well as the construction of an adjacent high-rise addition designed by architect Ernest Matthewson. The original building, located at the southeast corner of Sixth and Walnut Streets, was designed in 1913 by architect Edgar V. Seeler, who also designed the Curtis Building. On April 30, 1914, its granite cornerstone was laid, and in January 1916, Penn Mutual's fifth home was opened for business. The great bronze doors at Penn Mutual's Walnut Street entrance show the advance of civilization. The door's lower left figured panel depicts an insurance agent selling life insurance to a family. When the bronze doors are opened, the inner glass doors reflect the tower of Independence Hall. In advertising, Penn Mutual used an image of Independence Hall with its own building in the background, along with the slogan "Back of Your Independence Stands Penn Mutual."

The Marshall House is where Supreme Court chief justice John Marshall spent the closing period of his illustrious life. Built in 1799 at 422 Walnut Street, it was the Federal-style mansion of Benjamin Wistar. Marshall died here on July 6, 1835. From the old mansion, on July 8, 1835, a funeral procession escorted Marshall's body to the Chestnut Street wharf, wherefrom it was transported by boat to Richmond, Virginia. This photograph was taken around 1859. (Courtesy Independence National Historical Park.)

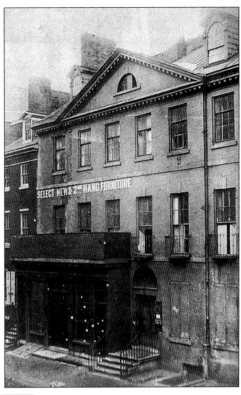

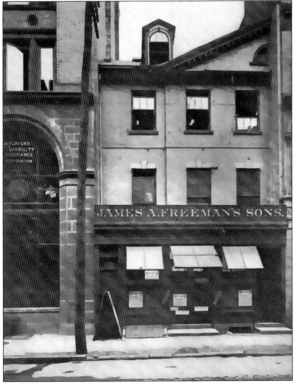

After Marshall's death, the mansion fell on hard times, becoming Crim's Boarding House, and later, James A. Freeman's Sons, the country's oldest auction house. This c. 1899 photograph shows the Teutonia Life Insurance Company at 424 Walnut Street (on left), the site of the Duane House, which was the matching half of the Marshall House.

The Philadelphia Contributionship for the Insurance of Houses from Loss by Fire was organized as a mutual fire insurance company with the help of Benjamin Franklin in 1752. The company, whose fire mark is four grasping hands, still operates from the 212 South Fourth Street building designed by architect Thomas U. Walter in 1836. Its outstanding architectural feature is its white marble porch.

When the Contributionship stopped insuring houses with shade trees, a second insurance company was formed in 1784 called the Mutual Assurance Company. Its fire mark is a spreading tree, known as the Green Tree. To indicate that a house was insured, fire marks were placed on the house's exterior. At right are four famous Philadelphia fire marks: Hand in Hand, the Green Tree, the Eagle, and Hydrant and Hose.

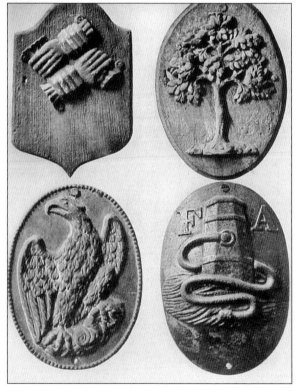

The Cadwalader House, shown about 1860, was built in 1829 by Joseph Norris. It was constructed on what was originally the side garden of the Shippen-Wistar House. In 1837, Judge John Cadwalader had his legal office and residence here, thus creating an unusual façade with two double doors—one to the office, the other to the residence. The building still stands at 240 South Fourth Street. (Courtesy Charles Peterson Collection.)

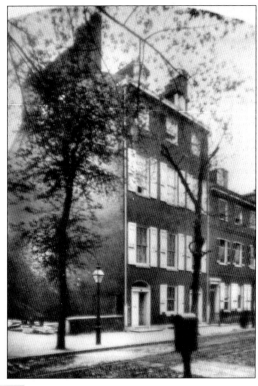

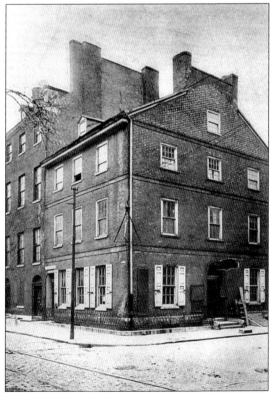

The Shippen-Wistar House, built about 1750, and the Cadwalader House had both fallen into disrepair when this c. 1911 photograph was taken. The Shippen-Wistar House, at the corner, once the center of Colonial Philadelphia social life, here had missing window shutters and frontispiece, and a broken gutter and downspout cascading water onto its walls. Fortunately, in 1913, both houses were combined and restored by architects Stewardson and Page, becoming the home of the Mutual Assurance Company.

Commo. David Conner led the U.S. Navy in the Gulf of Mexico during the Mexican War. Conner and his family lived at the northwest corner of Eleventh and Spruce Streets in a house leased from the Savage family. However, the Conners did not reside here for long; in 1841 Commodore Conner was appointed navy commissioner and the family moved to Washington. This *c.* 1800 Georgian-style town house is seen in 1888, one year before it was demolished.

In 1843, the Conner family moved to 247–249 South Fourth Street. The house had been built in 1810 for Chief Justice Benjamin Chew as his town house and was designed by architect Robert Mills in the Federal style. Commodore Conner died there in 1856, and his family lived there until 1878, when it was sold to the Pennsylvania Railroad Company, which greatly altered the house. (Courtesy Dell Conner.)

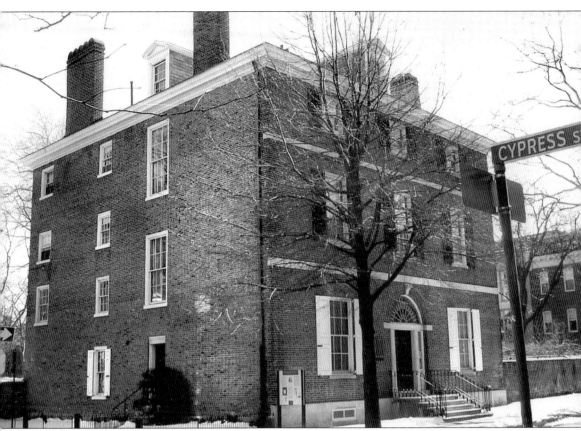

Society Hill's most beautiful Federal mansion was the Hill-Physick-Keith House, at 321 South Fourth Street. The last freestanding mansion in Society Hill, it was built in 1786 by wine merchant Henry Hill, and in 1790, it became the home of Dr. Philip Syng Physick, considered the father of modern surgery. The house was occupied by Physick's descendants until 1941. Its façade is one of elegant restraint, without the elaborate detail of the Georgian Period. The house and its walled side garden were restored in 1965. The Hill-Physick-Keith House is now a museum decorated with Federal-style furniture and is owned and operated by the Philadelphia Society for the Preservation of Landmarks.

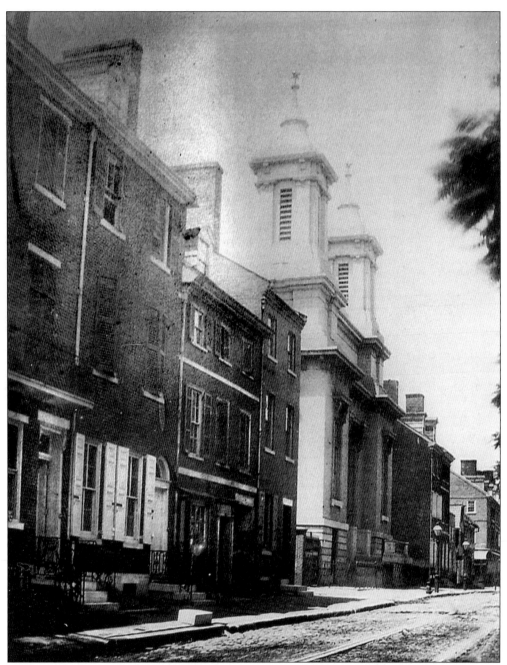

This c. 1860 photograph shows the Spruce Street Baptist Church, at 426 Spruce Street (now the Society Synagogue), when it had its two towers. The façade of the church was rebuilt in 1851 by Thomas U. Walter, a devote Baptist, who at the age of 30 had designed the original building in 1829. At the dawn of the 20th century, the ethnicity of the neighborhood changed, and in 1908, the Baptist congregation moved to the new trolley suburb of West Philadelphia. In 1912, the building was converted to a Jewish house of worship, the Great Rumanian Synagogue. The structure's Italianate design was altered, and Walter's towers were taken down after 1911. Since 1967, the synagogue has undergone extensive restoration. (Courtesy Independence National Historical Park.)

The Stride Madison House, at 429 Spruce Street, was the M. Feitelson and Sons rag warehouse in 1962, when it was photographed by historian Charles Peterson. From its appearance then, it would have been hard to believe that in 1795–1796 James Madison and his wife, Dolley, lived here when he was a member of the U.S. Congress. The house was restored in 1963. (Courtesy Charles Peterson Collection.)

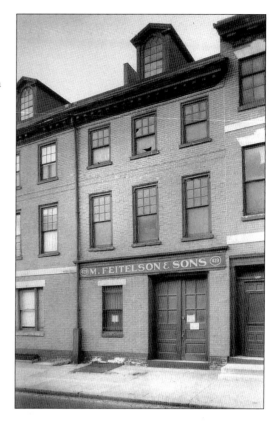

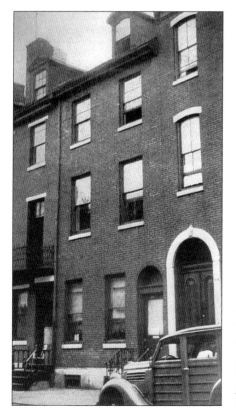

The house at 412 Spruce Street, photographed in 1939 by Joseph Jackson, still stands today. In 1818, it was the home of Eliza Leslie (1787–1858). As a young lady, Leslie attended cooking school and is known for writing cookbooks, including *Seventy-five Receipts for Pastry, Cakes, and Sweetmeats*, and the best-selling *Miss Leslie's Cook Book*.

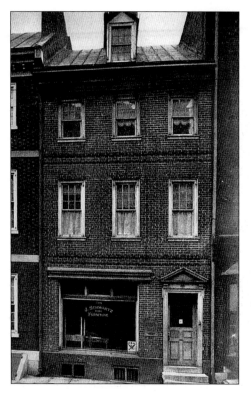

Francis Hopkinson was one of the signers of the Declaration of Independence; he also composed music. Hopkinson composed the tune for "Hail Columbia!" for which his son Joseph later wrote the lyrics in this house at 338 Spruce Street. Built about 1785, the residence became a store in 1909. This c. 1939 photograph still shows a storefront on the first floor. Now called the Williams-Hopkinson House, it was restored in 1964.

The Pancoast-Lewis-Wharton House, seen here about 1912, was built at 336 Spruce Street in 1790 by carpenter Samuel Pancoast. This elegant Federal-style home was the birthplace and residence of Joseph Wharton, founder of the prestigious Wharton School of Finance of the University of Pennsylvania. Since 1962, it has been the rectory of Christ Church; the house was restored in that year.

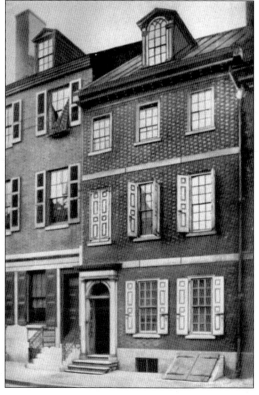

Named after Stephen Girard, Philadelphia financier and philanthropist, these five row houses at 326–334 Spruce Street were built in 1833 as investments. William Struthers was the mason who surfaced the ground floor of these Federal-style homes with marble. The Girard estate eventually sold them to preservationist Lawrence M. Smith, who in turn put them up for auction in 1954. Historian and architect Charles Peterson was able to purchase Nos. 332 and 334 Spruce Street for $8,000 each. Peterson found that the houses were extremely well constructed. He restored them, making several apartments and his own residence, where he lived until his death at the age of 98 in 2004. These photographs were taken by Peterson in 1959. The neighboring Pancoast-Lewis-Wharton House, at 336 Spruce, can be seen on the right side of the below photograph. (Courtesy Charles Peterson Collection.)

Founded in 1733, St. Joseph's Church is the oldest Roman Catholic church in Philadelphia. The present church, seen here in 1926, was built in 1838 on the site of the earlier 18th-century structure. It was hidden away in narrow Willings Alley and was accessible only through an archway leading to an inner courtyard, perhaps to keep a low profile in perilous times for the Church. It was probably the reason why St. Joseph's survived Philadelphia's anti-Catholic church-burning riots of 1844. On the north wall, a plaque pays tribute to William Penn for the religious tolerance he brought to the English colonies.

Old St. Paul's Church, located opposite Willings Alley on Third Street, was built in 1761 by architect Robert Smith, who also designed St. Peter's Church. Stephen Girard was married here, and in the front yard is the tomb of Edwin Forrest, the "Father of Theater" in Philadelphia. The church was greatly altered in 1830 by architect William Strickland, whose façade design can be seen in this 1926 photograph.

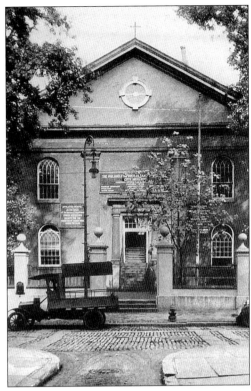

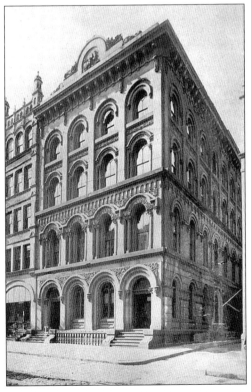

Opposite Old St. Paul's Church was the Lehigh Valley Railroad Company building, at the southwest corner of Willings Alley and South Third Street. Built about 1856, the building was designed in the Italianate style by architect Stephen Decatur Button and was a very early intrusion of commercial structure in this residential block. This 1898 photograph shows where one of the Balcony Houses at 230 South Third Street had already been replaced by an office structure.

The Winder Houses, sometimes referred to as the Balcony Houses, are situated at 232–234 South Third Street. Originally built as three Greek Revival houses in 1844, only two remain today. The houses' cast-iron ornamental balconies were removed in 1950. They have since been restored; No. 234 bears a griffin design, which is the original balcony rescued by Mrs. C. Jared Ingersol, and No. 232 has a copy of the running greyhound design.

The house at 242 South Third Street was built around 1850 on the site of an earlier house, the residence of John Penn, last Colonial governor of Pennsylvania, and George Washington, who lived there in the winter of 1781–1782. Until 1810, it was the town house of the chief justice of Pennsylvania, Benjamin Chew, who also taught law there to young Francis Hopkins. This c. 1939 photograph shows the house and the neighboring Powel House's doorway.

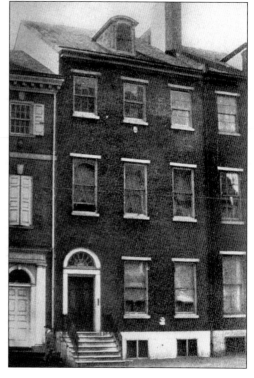

This 1962 photograph depicts the Rowley-Pullman House, at 238 South Third Street. Built in 1825, it looked much like the neighboring houses on the block of that period until 1888, when it was given a fashionable new façade by architect Wilson Eyre.

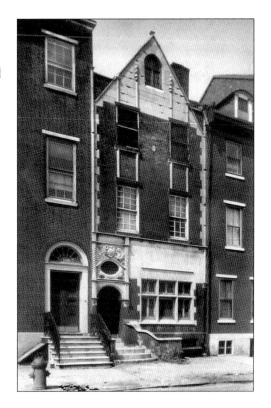

In 1963, the owner of Rowley-Pullman House wanted to restore the original façade. This caused a controversy within the Philadelphia Historical Commission about whether to save the Wilson Eyre façade—which was also considered historical—or to return the building to it original design. The "colonialists" won, as evidenced by this photograph showing the house as it looks today.

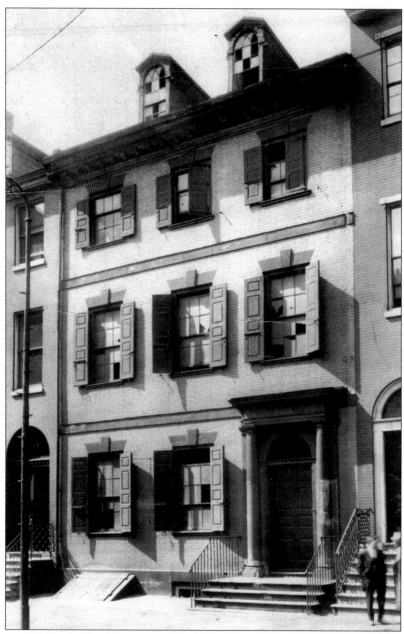

The home at 244 South Third Street was originally built for Charles Sedman by architect Robert Smith in 1765. Samuel Powel, called "the Patriot Mayor," purchased it in 1768. Although the house was not the largest in Philadelphia, Powel's Georgian town house was certainly one of the most elegant, featuring a second-floor ballroom with a Waterford crystal chandelier and gilt mirrors. Here, Elizabeth, Samuel Powel's wife, hosted the greats of the Revolution. Samuel Powel died in Philadelphia's yellow fever epidemic of 1793, but his relatives continued to live in the house until 1833. In 1904, Wolf Klebansky, a Russian Jewish immigrant, bought the Powel House. In a factory workshop in the rear of the house, he made products from Russian horsehair and bristles. Around 1907, when this photograph was taken, the Colonial Dames of America informed Klebansky that he owned a historic landmark. (Courtesy Dell Conner.)

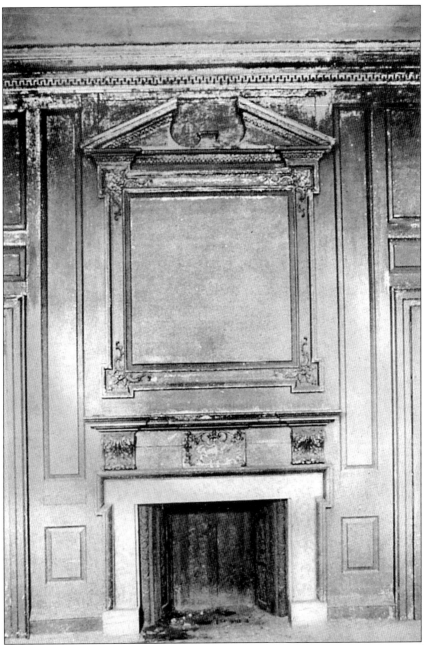

This c. 1907 photograph of the fireplace and over-mantel in the bedchamber of the Powel House shows that the elegantly carved woodwork and fireplaces remained intact even though the house was in disrepair. In the 1920s, owner Wolf Klebansky sold the woodwork and fireplaces of the ballroom to the Philadelphia Museum of Art, and the Metropolitan Museum of Art in New York City bought the supper room's woodwork. In 1930, Klebansky wanted to tear down the house for a garage. Through the efforts of Francis Anne Wister, who mobilized support for the house, it was bought and saved from demolition. Wister then founded the Philadelphia Society for the Preservation of Landmarks in 1931. The Powel House has since been restored, and the missing woodwork and fireplaces expertly replicated. It is open to the public as a museum.

Named for Michel Bouvier, great-grandfather of Jacqueline Bouvier Kennedy, the Bouvier House, at 260 South Third Street, is part of a row of three—from 258 to 262—that are among the few brownstones in Society Hill. They were built in 1848 in an Italianate style just three years after John Notman's Italianate design for the Athenaeum. In 1854, Bouvier moved to a large Italianate villa at Broad and Stiles Streets in North Philadelphia.

Built around 1815 and likely the design of architect Robert Mills, the Mitchell-Thomas House was located at the northwest corner of Third and Spruce Streets. The brick arches over the windows are a design motif often used by Mills in his houses. A three-story addition along Spruce Street was added about 1850. This 1962 photograph was taken two years before the structure was demolished. (Courtesy Charles Peterson Collection.)

David Hill's house, located at 309 South Third Street, was a likely candidate for demolition when this photograph was taken in 1959. The house was built about 1839 in the Federal style, and the ground floor was made into a store at a later date. As this image shows, it was clumsily "remuddeled" back into a residence. In 1971, the house's façade was restored to its original design. (Courtesy Charles Peterson Collection.)

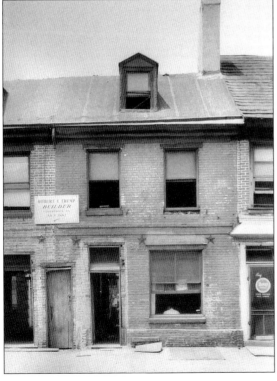

Carpenter John Piles built this "bandbox" house in 1772. Located at 328 South Third Street, it was in wretched condition when this photograph was taken in 1959. Three star bolts were the only things keeping the house's façade from crumbling onto the sidewalk. The house was later restored by builder Robert T. Trump (Courtesy Charles Peterson Collection.)

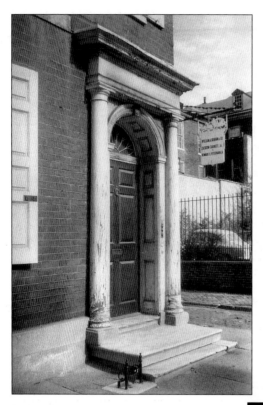

The elegant Federal-style doorway to the historic Berry-Coxe House, at 413 Locust Street, was built around 1807, likely by carpenter Peter L. Berry. It is shown here in 1958, while the house was being used as offices. Although in need of painting, the original Tuscan frontispiece and fanlight were intact. The house was restored in 1959–1960. (Courtesy Charles Peterson Collection.)

A Greek Revival–style entrance is shown in this 1926 photograph of the Stone-Penrose House, at 700 South Washington Square, which still stands today. Built in 1818 for merchant Asaph Stone, the residence has all the characteristics of that period: a white-marble stoop, foot scraper, fanlight over the eight-panel door, elegant wrought-iron railings, and Venetian shutters.

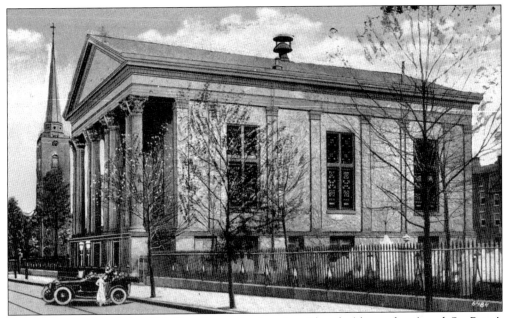

The congregations of the Old Pine Street Presbyterian Church (shown here) and St. Peter's Anglican Church stayed the course and did not relocate as Society Hill deteriorated. Old Pine was built at 412 Pine Street in 1768 and was designed by architect Robert Smith. The Greek Revival portico was designed by John Fraser, who in 1857 extended the façade to Pine Street's sidewalk. During the Revolution, the British used the church as a hospital and as a stable.

At 313 Pine Street, the c. 1786 St. Peter's Anglican Church was designed by Robert Smith, who gave it an oversized Palladian window. In 1842, William Strickland designed the tall tower and spire of the church. At rest in the graveyard are artist Charles Wilson Peale, Commo. Stephen Decatur, banker Nicholas Biddle, and several American Indian chiefs, among others.

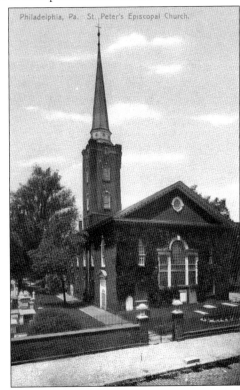

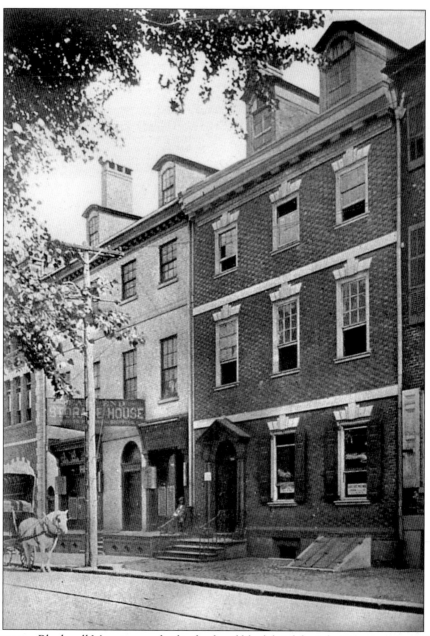

The Stamper-Blackwell Mansion was built of red and black brick by John Stamper about 1768 at 224 Pine Street. Stamper was an alderman and Philadelphia mayor in 1759. At a later date, the house passed to Dr. Robert Blackwell, who also built a house at 238 Pine Street for his daughter upon her marriage. This c. 1900 image shows the house as a run-down tenement. By 1907, the house's front rooms had been converted into a union meeting hall for Jewish shirt cutters and shirtwaist makers, who eventually joined the International Ladies' Garment Worker's Union. The house was described in a 1912 book on Colonial homes as "being mutilated and dingy—it now serves as a house for immigrants and some front chambers are rented to socialist clubs: squalor unspeakable prevails." Old Philadelphia society was obviously not amused at the mansion's demise. The house was completely demolished in 1921.

The Charles Massey House, at 239 Pine Street, was still a residence when this 1915 photograph was taken. Similar in design to the Stamper-Blackwell Mansion across the street, it likely dates from the same period, about 1760. Restored, it remains standing today.

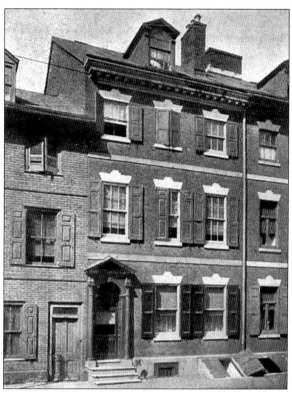

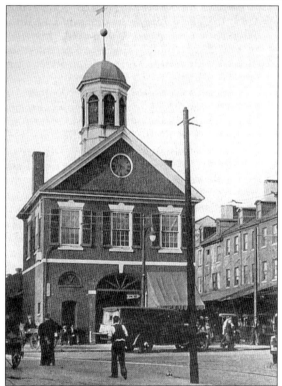

In 1745, open sheds were erected in the middle of Second Street to allow merchants a marketplace to sell food and wares. At the Pine Street end of the sheds, called "the shambles," the Head House—a fire engine house with a bell tower cupola—was built in 1804. In this 1939 photograph, the Pine Street Head House is surrounded by warehouses and factories. The house and the shambles were restored in the 1960s.

This c. 1900 view shows South Street, looking west from the south end of the Second Street shambles. At the northwest corner of Second and South Streets stood a row of five-story Federal houses that were now shabby tenements, warehouses, and shops. South Street's sidewalks and shops were full of immigrant merchants and shoppers speaking every language but English. The street was the center of what was then called the Jewish Quarter. It was not like the Jewish ghettos of Eastern Europe, but rather a springboard from which new Americans and their children could eventually assimilate into mainstream society. However, at that time, South Street and the newly arrived immigrants were anathema to those who called themselves "patriotic Philadelphians," like elitists Joseph and Elizabeth Pennell, who were not timid about publishing their disdain for the new arrivals.

Two

DELAWARE AVENUE AND DOCK STREET

Delaware Avenue was widened to 50 feet in the 1840s in order to accommodate the commerce of that day. As Philadelphia's importance as a commercial center increased rapidly over the years, the avenue's traffic congestion became intolerable. Railroad tracks ran down the middle of the avenue, and everything that crossed the Delaware River to New Jersey had to be unloaded and put on ferryboats. The avenue was widened to 150 feet in 1897–1899. Every major eastern railroad had a pier there. This c. 1904 postcard view shows the improved Delaware Avenue, looking north from Chestnut Street to the Pennsylvania Railroad Ferry pier.

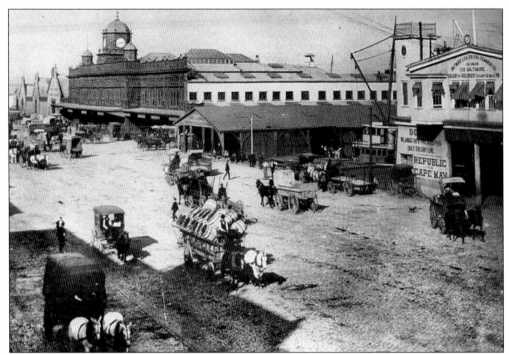

From the Chestnut Street pier, seen above about 1900, one could travel to Cape May or take the Ericsson Line steamboat to Baltimore. To go by train to New Jersey, one had to take a ferry from the Pennsylvania Railroad Ferry pier at the foot of Market Street and reconnect with the electric railroad on the Camden side of the river. In 1926, just in time for Philadelphia's sesquicentennial exposition, the Delaware River Bridge was opened, eliminating the necessary ferry ride to visit New Jersey's shore resorts. Below is an 1898 photograph of Delaware Avenue showing the domed Pennsylvania Railroad Ferry pier.

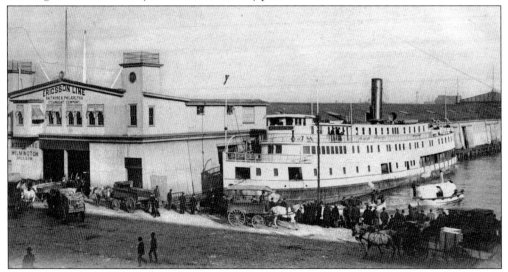

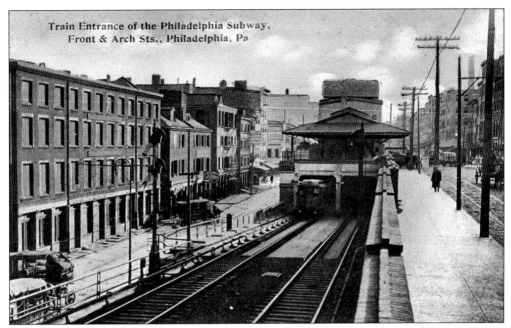

The Market Street Subway-Elevated line opened in 1908. It exited aboveground on Front Street at Church, just north of Market, and then headed north up an inclined slope to Arch Street, where it made a U-turn above the street and started south on Delaware Avenue. This c. 1910 postcard view, looking south, shows the elevated trains' tunnel entrance with a trolley stop above. Water Street is on the left.

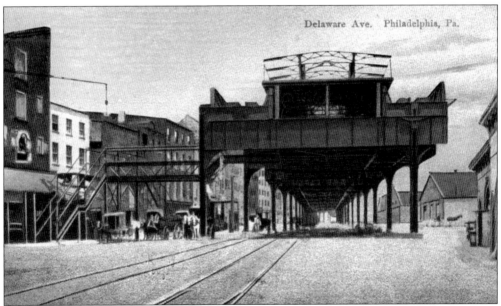

The Delaware Avenue line ended abruptly at the South Street station. The avenue was lined on its west side with warehouses, freight depots, and sugar refineries. The only other station on the Delaware Avenue line was at Market Street, where passengers could connect with the Pennsylvania Railroad Ferry at the foot of Market Street. The Delaware Avenue line was demolished in 1922 with the construction of the Frankford Elevated line.

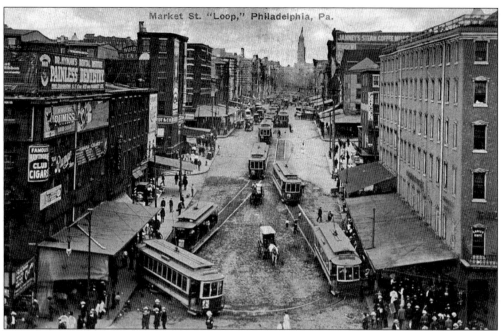

This c. 1904 postcard of the Market Street trolley loop illustrates why it was deemed necessary around 1906 to construct the Market Street Subway-Elevated to alleviate the street's traffic congestion. On the right is the Ridgway House Hotel, with large sidewalk canopies to protect waiting trolley passengers. City Hall, the undisputed tallest building in Philadelphia at that time, can be seen in the distance

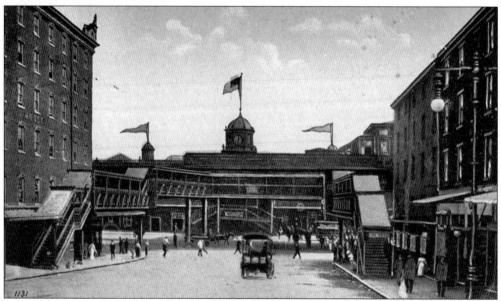

After 1908, the trolley loop was removed from Market Street, and an elevated station for the Delaware Avenue line opened to the public. The tower seen behind the elevated station is the Pennsylvania Railroad Ferry building, which was big enough to dock four boats. On Delaware Avenue, between Chestnut and Walnut Streets, was the Reading Railroad Ferry pier, which could dock two boats.

One of the early-19th-century warehouses was this one at 105 Delancy Place that had a half-gambrel roof. Surrounded by other warehouse buildings in this 1959 photograph, it was later demolished in 1961. New town houses now occupy the site. (Courtesy Charles Peterson Collection.)

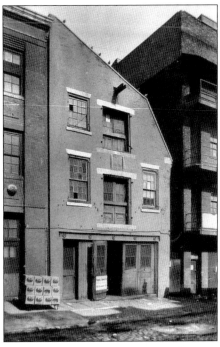

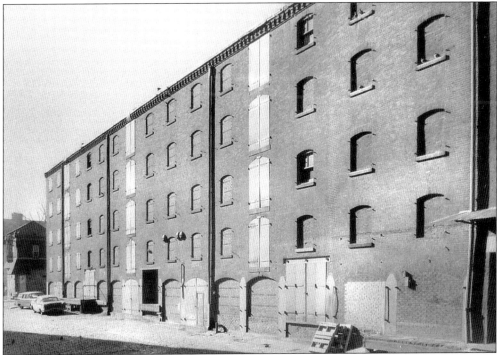

The U.S. Bonded warehouse, at the southeast corner of Front and Lombard Streets, was five stories high on Water Street and three stories high on Front Street. This 1959 photograph was taken looking south on Water Street, toward Lombard. The building was designed in 1853 by architect John McArthur Jr. in a style similar to warehouses built on London's docks in the 19th century. It was demolished in 1967. (Courtesy Charles Peterson Collection.)

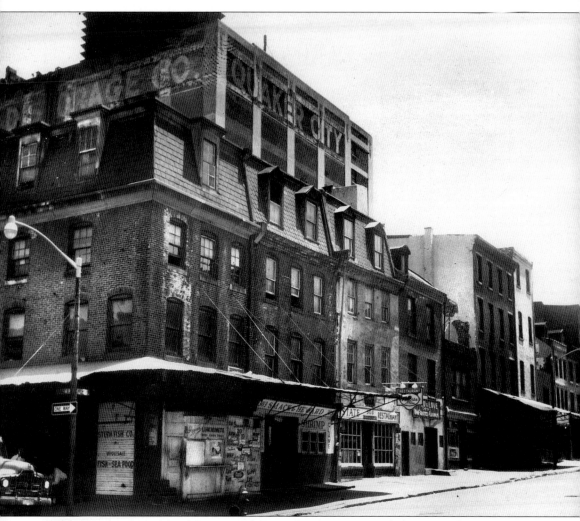

At the southeast corner of Spruce and Front Streets once stood the original store of Jacob Reed and Sons clothiers, in a building at 301–303 South Front Street that dated from the 18th century. In the 1860s, the three mansard-roofed buildings seen here were built on the site. When this c. 1950 photograph was taken, the area was a part of the wholesale food market, and derelict in appearance. The uppermost floors of the buildings sat vacant. This block and the huge Quaker City warehouse in the background were all demolished in 1967 for the construction of Interstate 95. Today, modern town houses stand on the opposite side of Front Street, overlooking the depressed Interstate 95 expressway.

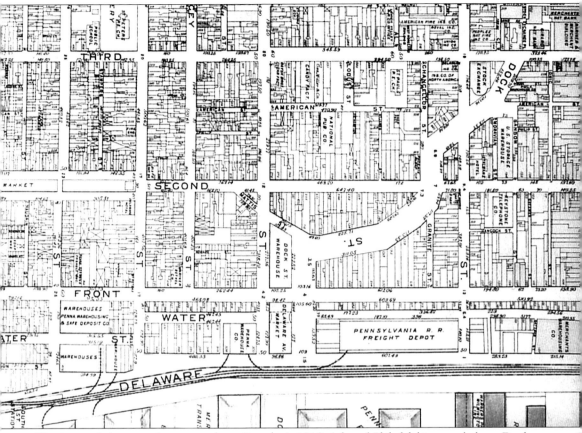

This map of the waterfront area from Bromley's 1910 *Atlas of Philadelphia* reveals how Dock Street followed the curved path of the old Dock Creek on which it was built in 1784. Dock Street cut through the 1683 grid pattern of Philadelphia laid out for William Penn by Thomas Holme. This map also shows the density of the Society Hill and Old City area at the time, with packed blocks of Colonial houses, alleyways and inner courts, and no open space except for the occasional church graveyard. Many of the houses were warehouses, sweatshops, shops, and rooming houses for newly arrived immigrants. Society Hill would have to wait another 50 years before being rediscovered as a national treasure.

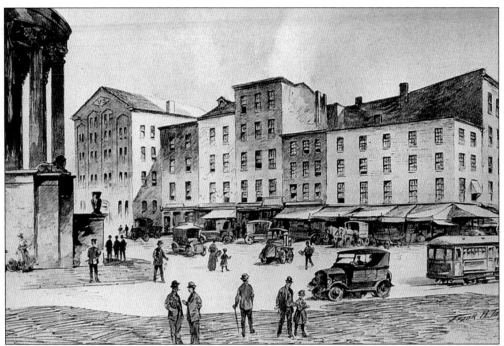

Artist Frank H. Taylor drew this idealized sketch of Dock Street (above) about 1914, as it may have looked in the late afternoon after the hurly-burly of the day's commerce was done. To the left is the curved portico of the Merchants' Exchange at Dock and Walnut Streets. The buildings on the right were demolished around 1925 in order to build the Seamen's Church Institute (below), at 211 Walnut Street, which could house 200 men. The institute had produce stores and a sidewalk canopy on its Dock Street side, in keeping with the rest of the Dock Street area.

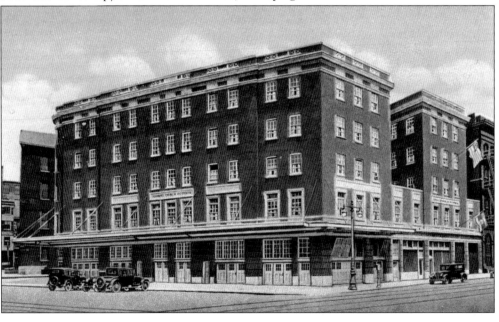

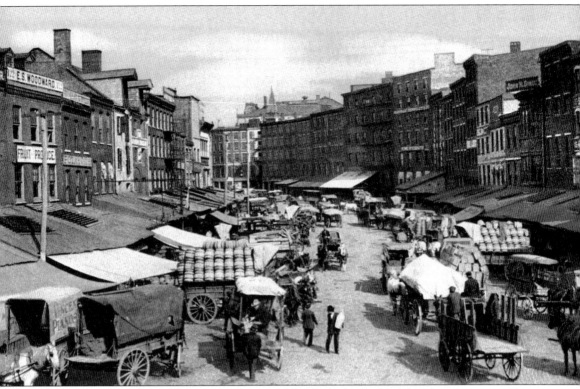

For almost 100 years, Dock Street was Philadelphia's wholesale food distribution center. Tin shed roofs covered the sidewalks that were used as loading docks and storage areas. Every year, millions of dollars' worth of live chickens, fish, and fresh produce that came directly from the ships arriving at Delaware Avenue's piers were wholesaled here. Even in 1908, when this postcard was made, the street was barely able to cope with the horse-and-wagon traffic. Over time, the area deteriorated, and with the advent of motorized trucks, the market almost ceased to function due to congestion and unsanitary conditions. In the 1950s, a new food distribution center was built in South Philadelphia, paving the way for Society's Hill renewal. One evening in 1959, the Dock Street Market finally closed. Society Hill Towers were then built on the site and were completed in 1964.

In 1819, Joseph Eastburn organized the Mariner's Bethel Church, one of the country's oldest seamen's churches. This 1961 photograph shows the Front Street façade of the church, which stood at the southwest corner of Front and Delancy. Possibly designed by architect Stephen D. Button, the church had a square clock tower on its front roof peak until it was removed in 1912. The Mariner's Bethel Church vacated the building in 1959 and merged with the Third Presbyterian Church. A fire ruined the church's interior in 1963, and the building was demolished in 1971. (Courtesy Charles Peterson Collection.)

Three

CHESTNUT STREET AND BANK ROW

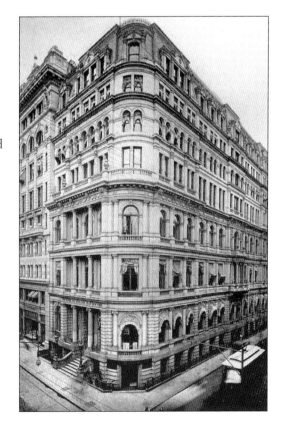

At Society Hill's western edge, at the northwest corner of Tenth and Chestnut Streets, is the Victory Building, constructed for the Mutual Life Insurance Company of New York. It opened in 1875, just in time for Philadelphia's centennial exposition. Architect Henry Fernbach designed the Second Empire–style building, which was originally only five stories high. In 1890, the fourth-floor mansard roof was taken off above the third-floor balustrade, and an additional four stories were added. A 10-story addition, seen at the left of the building, was constructed in 1901. By the 1980s, the building had become derelict, with pieces of the cornices falling onto the sidewalk—a prime example of demolition by neglect by its speculator owner at the time. Due to public outcry, the building was saved and eventually restored as a dormitory for Thomas Jefferson University.

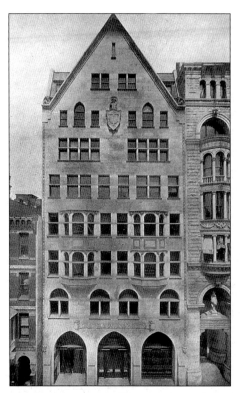

Architect Wilson Eyre Jr. designed this extraordinary building for the City Trust, Safe Deposit, and Surety Company at 927–929 Chestnut Street in 1888. Eyre gave the façade a dominant shape and repeated it in the windows and entrances, a design motif he also applied to his residential work. Over the entrance is an art nouveau–style banner with the company name. The building's design was in sharp contrast to that of its ornate neighbors.

Designed by architect Theopholis Chandler Jr., the Penn Mutual Life Insurance Company, with its high clock tower, stood at 921 Chestnut Street. Chandler studied the picturesque architecture of France's Loire Valley and mixed it with classical details to produce an impressive façade designed to assure the policy holders of the insurance company's reliability. Architect Frank Miles Day's office occupied the entire top floor of the building in 1899, when this photograph was taken.

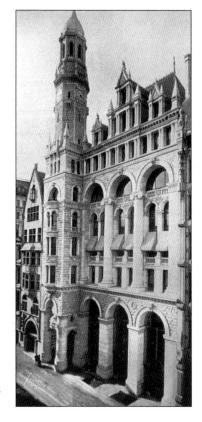

The Philadelphia *Record* was the *Public Record* when William M. Singerly took it over in 1877 and made it a phenomenal success. In 1887, he constructed this building at 917 Chestnut designed by architect Willis Hale in an Eastlake style. The *Record* was a strong supporter of the Democratic Party and was particularly popular with the working man. As a result, the newspaper helped Singerly, who lived in a mansion on North Broad Street, become very rich.

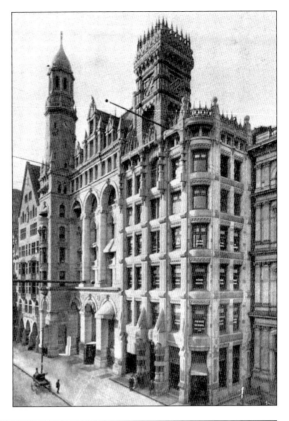

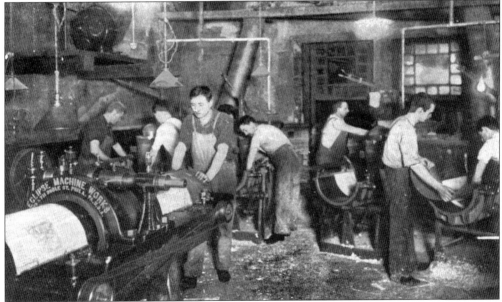

In 1910, the *Record* published a 12-piece postcard series showing the newspaper's operations, including a view of the stereotyping room (which would never meet today's OSHA work-safety standards). The facility was in sharp contrast to the modern working conditions shown in a similar series printed by the Curtis Publication Company about the same time (seen on page 78).

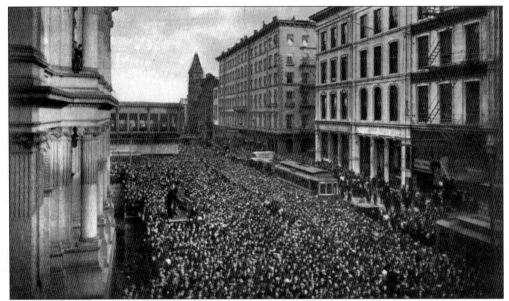

The *Record* placed an electric baseball scoreboard in front of its building for the 1910 World Series. Thousands of fans jammed Ninth and Chestnut Streets to see the scores as each game proceeded. That year, the Philadelphia Athletics won the World Series by beating the Chicago Cubs. This postcard was published as part of a series by the *Record* in 1910.

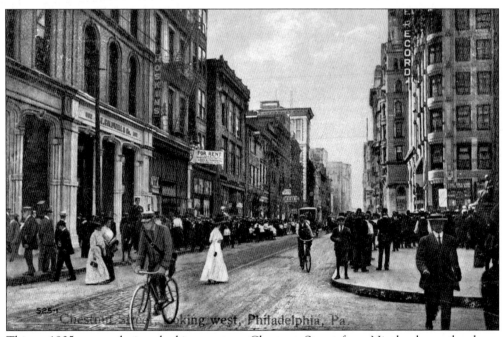

This *c.* 1905 postcard view, looking west on Chestnut Street from Ninth, shows the dense population of that commercial area. In later years, Philadelphia's center of commerce moved west to Broad Street, near City Hall.

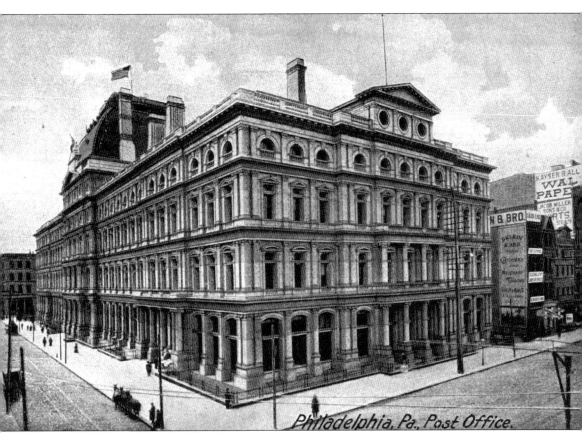

On the site of the 1797 Presidents' Mansion, the first home of the University of Pennsylvania, was the U.S. Post Office and Federal Building. Viewed here from Market Street, it was built from 1873 to 1884 at Ninth Street, running the full block between Market and Chestnut. The supervising architect was A. B. Mullet, and John McArthur Jr. was credited as being the architect. It took 11 years to build. Made of granite and constructed at a cost of $7,265,487.77, it was created in a Second Empire style reminiscent of the Louvre pavilions in Paris. On the Chestnut Street plaza stood Benjamin Franklin's statue. In 1934, when the building was demolished, the sculpture group by Daniel Chester French on the top of the main pavilion was relocated to George's Hill in Fairmont Park. An identical federal building is still standing in St. Louis, Missouri. Its image is on a 13¢ U.S. postcard issued in 1982.

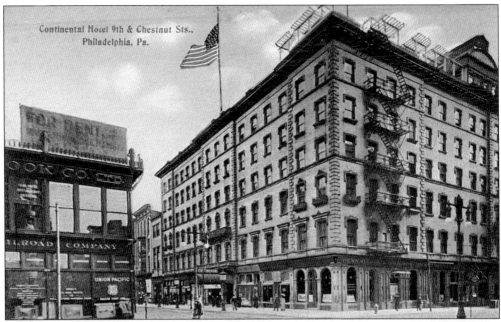

The Continental Hotel, located at the southeast corner of Ninth and Chestnut Streets, was built in 1860 and designed by architect John McArthur Jr. This c. 1910 postcard view shows the hotel's main entrance on Chestnut Street. Guests included Edward VII, Prince of Wales, and Charles Dickens, who found Philadelphia "a handsome city but distractingly regular." The old Continental Hotel was demolished in 1924 to make way for the construction of the Benjamin Franklin Hotel, which now occupies the entire block.

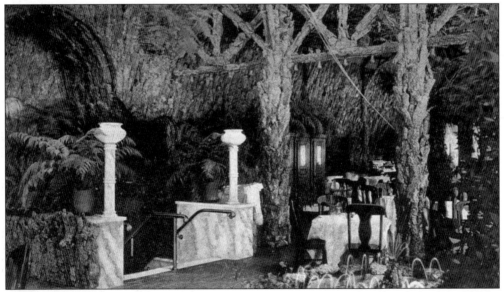

Before the invention of air-conditioning, and typical of large hotels of the period, the Continental Hotel had a roof garden to catch the cool summer breezes. Guests could dine there, far removed from the noises and smells of the city streets below. This 1908 postcard shows the hotel's roof garden with walls, columns, and beams covered in real tree bark. This fire marshal's nightmare could not be reproduced today.

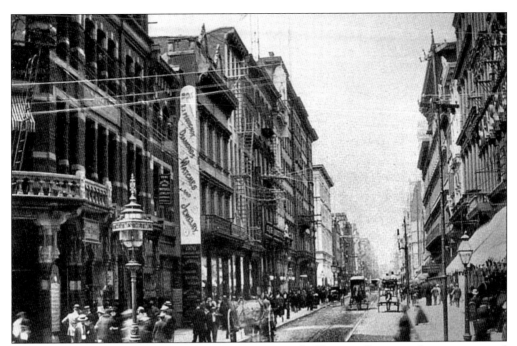

Looking west from Eighth Street, this 1898 view reveals Chestnut Street, with an ornamental gas light on the southwest corner advertising the *Times* newspaper. Telephone lines crisscrossed Chestnut Street like a spider web. At the end of the block, on the left, the six-story Continental Hotel is visible.

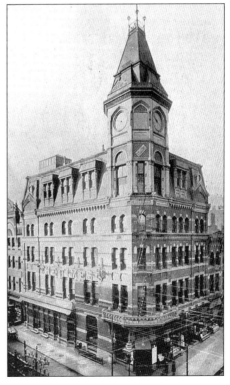

At the southwest corner of Eighth and Chestnut Streets was the Times Building, constructed in 1880 and designed by the Wilson Brothers. The *Times* was published by Col. A. K. McClure, a prominent figure in Philadelphia civil and political life. The paper was founded in 1877 and merged with publisher Adolf S. Ochs's *Ledger* in 1901. Like the neighboring *Record*, the *Times* was Democratic in its editorial policies.

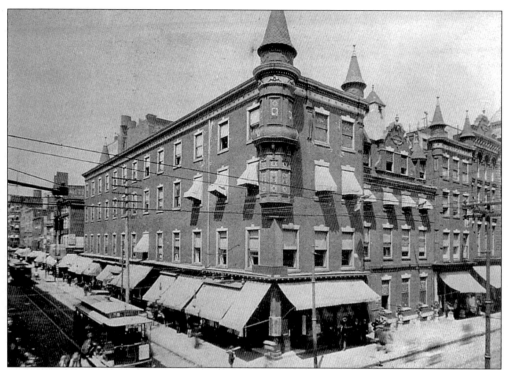

Green's Hotel, on the northeast corner of Eighth and Chestnut Streets, was a gathering place of politicians, artists, and sportsmen. In the above 1898 photograph, a new electric trolley travels south on Eighth Street. When the hotel was opened in 1866, owner Thomas Green incorporated into the design the neighboring former home of Edward Shippen, chief justice of Pennsylvania in Colonial times. Green kept the room in which Peggy Shippen and Benedict Arnold were married. In an era of good living and easy spending in the late 1890s, the hotel's famous bar was a place in which one was to be seen. With the advent of prohibition, all that ended, and in 1934, the building was demolished. Below is a postcard view of the hotel's plush lobby; the card was postmarked the year the hotel closed.

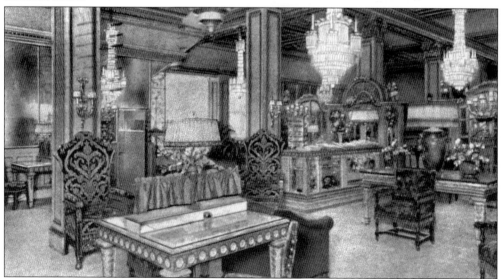

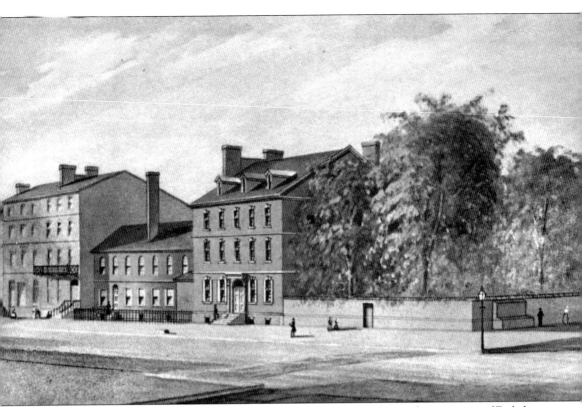

The mansion of Maj. Pierce Butler was built in 1794 and located at the northwest corner of Eighth and Chestnut Streets. In 1812, Major Butler owned 638 slaves and was one of the wealthiest men in the country. His grandson Pierce Butler stood to inherit this fortune and become one of the largest slave holders in the nation when he met English actress Fanny Kemble in 1832. Pierce became infatuated with Fanny after seeing her perform. They were married in 1834 in Philadelphia. The marriage was troubled nearly from the start because of differences in opinion on slavery. Pierce thought he could persuade Fanny of the benefits; Fanny thought she could persuade Pierce to emancipate his slaves. She soon gave up and divorced him, and then resumed her stage career. The house was demolished in 1856.

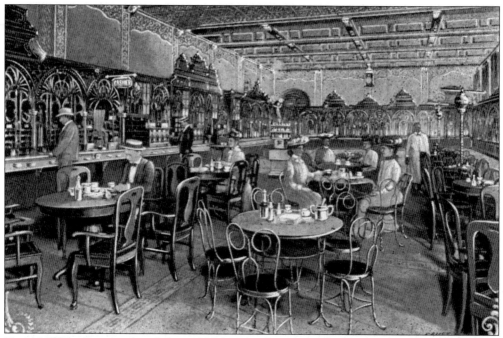

Horn and Hardart was founded in 1888 by Joseph V. Horn and Frank Hardart, and the first lunchroom was opened in Philadelphia in 1888. In 1902, at 818 Chestnut Street, the company opened its first Automat, seen above, which employed "waiterless restaurant" equipment imported from Berlin. The first New York City Horn and Hardart Automat opened in 1912 in Times Square.

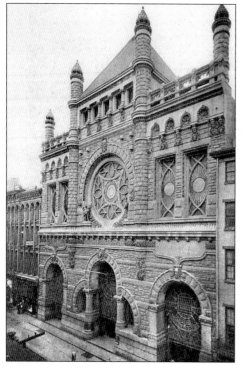

Perhaps the most bizarre architectural design for a Philadelphia insurance company was Willis Hale's plan for the Union Trust Company, built in 1888 at 715 Chestnut Street, a few doors east of Green's Hotel. It was Hale's oriental fantasy, complete with four minaret towers. In 1929, the façade of the building was changed to a classical style by architect Paul Cret, who left only the extreme left bay intact.

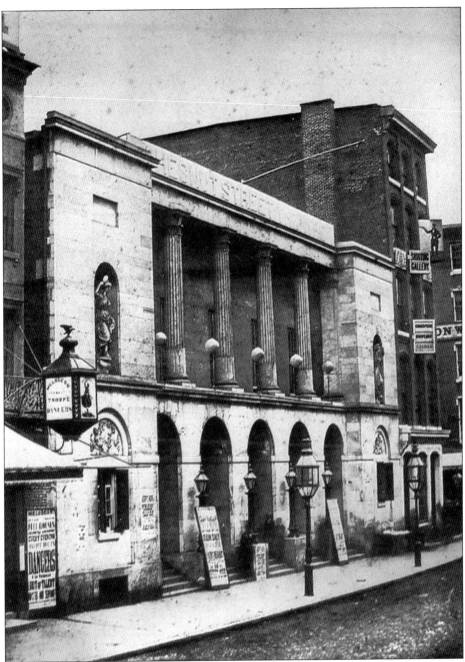

In the 1820s, Philadelphia witnessed a busy decade of theater building. When the old 1793 Chestnut Street Theater at 603–609 Chestnut Street burned down in 1820, immediate plans where made to rebuild. William Strickland, well known for his Greek Revival architecture, was chosen to design the new theater. Strickland reused the statues of *Tragedy* and *Comedy* saved from the fire ruins and placed them in niches on the exterior of the new building. The New Theater opened on December 2, 1822. However, like many Philadelphia theaters, it was short-lived and was demolished in 1859, just after this photograph was taken. (Courtesy Independence National Historical Park.)

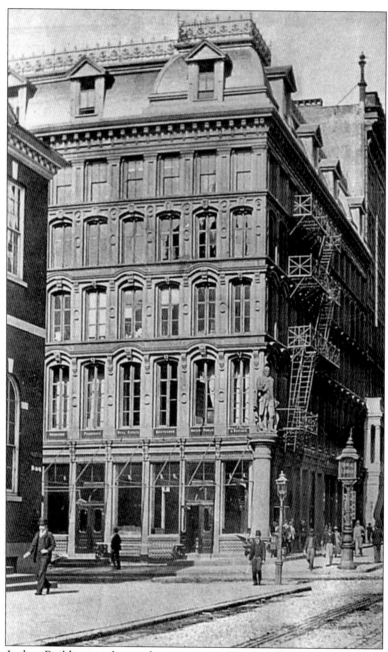

The Public Ledger Building, at the southwest corner of Sixth and Chestnut Streets, was built in 1868 and designed by John McArthur Jr. Placed conspicuously on a column at that corner of the building was a statue of Benjamin Franklin. The Second Empire structure was heralded as one of the finest buildings of its type in the country when it opened. The owner of the *Public Ledger* was George W. Childs, a close friend of financier Anthony J. Drexel. The two walked to work together and lunched every afternoon in Drexel's office. Childs made the *Public Ledger* the most successful and most conservative paper in Philadelphia. In 1926, the building was demolished to construct a new Public Ledger Building designed by architect Horace Trumbauer, who consciously created a design that harmonized with the neighboring Curtis Publication Building.

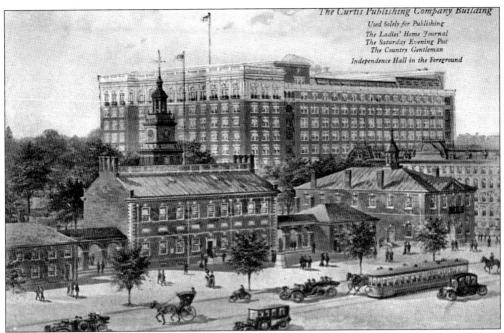

In 1910, the cornerstone was laid for the Curtis Publication Building, located on the western end of Independence Square at Sixth Street. The building was designed by Edgar V. Seeler in the Colonial Revival style to match Independence Hall, seen in the foreground of this postcard view. Curtis published the Ladies' Home Journal, the Saturday Evening Post, and the Country Gentleman, and at one time employed 4,000 workers.

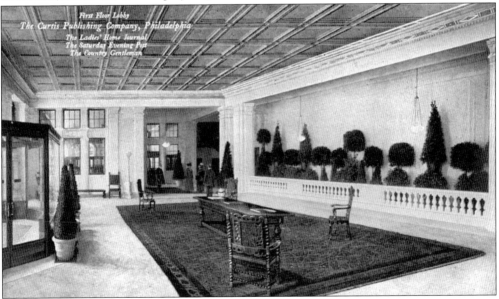

When the Curtis Publication Building lobby first opened, Louis Comfort Tiffany's glass mosaic mural The Dream Garden had not yet been installed on its wall. The mural, based on a painting by artist Maxwell Parrish, was placed there around 1915. Now designated a "historic object," Tiffany's mural remains in the Curtis Building's lobby after a long court battle over its ownership was recently settled amicably.

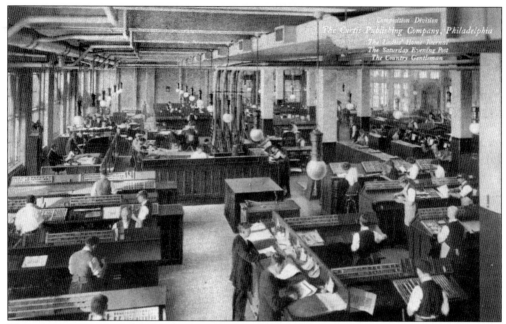

These images are part of a set of 12 postcards published around 1912 by the Curtis Publication Company showing the various work spaces in its building. Here, in the composition department, workers are still setting the letters by hand. The building was very modern for its day, with a pneumatic tube system, electric lighting, fireproof/sprinkler construction, and large windows providing plenty of natural light.

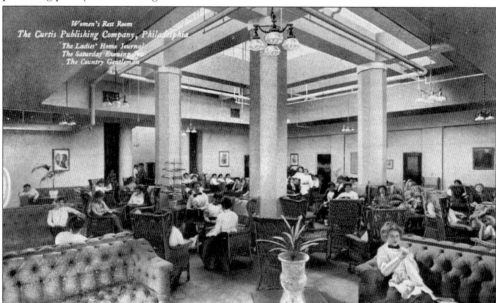

Some 1,800 office personnel once worked for publisher Edward Bok. He treated his female employees with comforts that many did not have at home. The sky-lighted women's restroom, shown here, looks more like a hotel lobby of the period, with plush couches and potted plants. Women employees even had their own spacious recreation room. Their working conditions were very different from the firetrap sweatshops many other women had to work in at that time.

This *c.* 1898 view of Chestnut Street, looking east from Sixth Street, shows a row of banks and insurance companies that once faced Independence Hall. In the background is the tall Drexel Building on Fifth Street. This block of Victorian buildings was demolished in the 1950s to make way for the construction of Independence Mall.

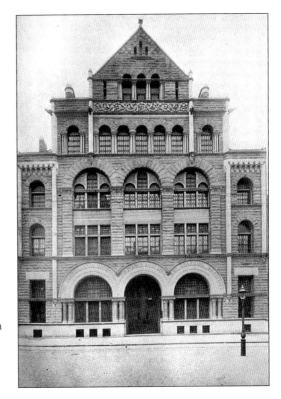

Directly opposite Independence Hall, at 517 Chestnut Street, was the massive Pennsylvania Company for Insurances on Lives and Granting Annuities building. It was constructed in 1886 and designed in a Romanesque style by architect Addison Hutton.

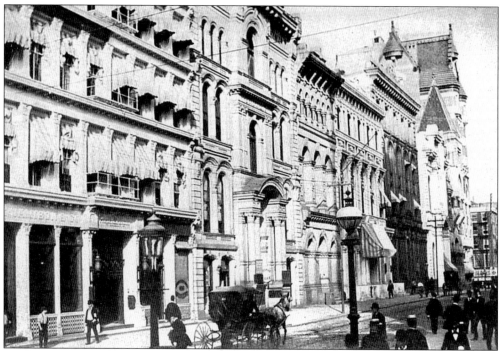

This c. 1898 photograph shows the north side of the 400 block of Chestnut Street. At the time of the 1876 centennial exposition, Philadelphia had more than 40 banks, including both savings and private banks. These institutions once lined lower Chestnut Street near Independence Hall. They were built of marble and granite, emphasizing the serious regard that Victorians had for money.

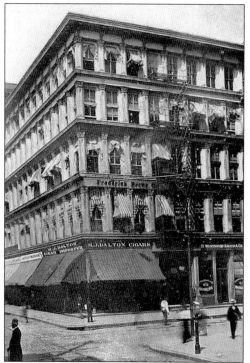

At the northeast corner of Fifth and Chestnut Streets was the building of the Frederick Brown Company, which manufactured drugs and chemicals. The building was erected in 1851, and was torn down to make way for the construction of the Lafayette Building in 1907. Frederick Brown was one of the principal founders of Laurel Hill Cemetery.

Still standing at 11 South Fifth Street is the Bourse Building, constructed in 1895 and designed by the Hewitt Brothers with a terracotta and brick exterior. The trading floor was a two-story, sky-lighted space surrounded by eight stories of offices. In 1982, the building was renovated into a shopping mall and offices, and the skylight was replaced by a new one at the top of the interior court.

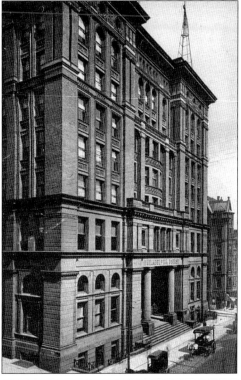

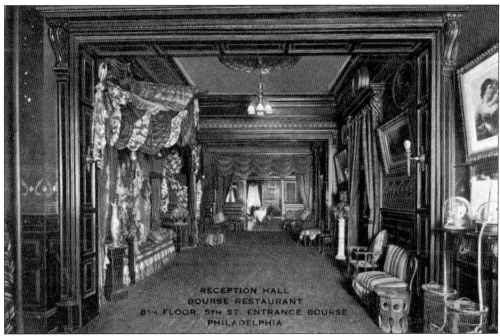

The reception hall to the eighth-floor dining room of the Bourse was a Turkish delight, which included a nook for smoking tobacco, seen on the left. Two tickertape machines kept brokers informed of stock market happenings. This very lush dining room was in contrast to the workers' spartan cafeteria in the building's basement.

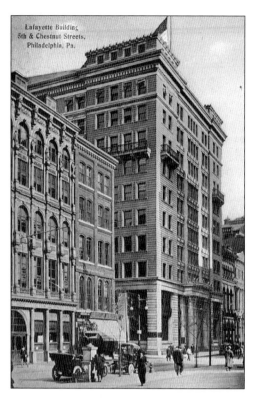

This 1910 postcard view shows the new Lafayette Building, constructed in 1907 at the northeast corner of Fifth and Chestnut Streets. Designed by architect John T. Windrim, it was a modern office building wrapped in an Edwardian terra-cotta style, with classical motifs at its entrance. Windrim was designing many important Philadelphia office buildings at the time. To the extreme left, the offices of the Trust Company of North America are visible.

Seen in 1899, the Trust Company of North America Building stood across from Independence Hall. It was designed in the 1870s in an Italianate style by the Wilson Brothers. Before air-conditioning, the awnings on this south-facing façade were a low-tech way of handling solar heat gain. The building was demolished in the 1950s to clear the way for Independence Mall.

The Farmers and Mechanics Bank, located at 427 Chestnut Street, is pictured here in 1899. It was built on the site of the bank's first building. Designed by architect John Gries in 1855 and built of white marble in an Italianate style, it included an impressive three-story banking room with a skylight in the rear of the building. The structure became a maritime museum in 1965.

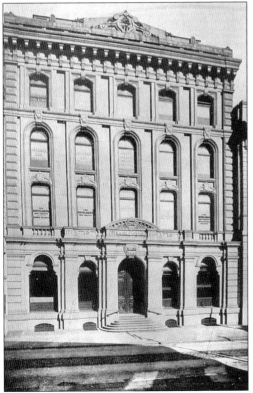

The Philadelphia National Bank building still stands at 421 Chestnut Street. This 1899 photograph shows the bank's granite Italianate façade, as designed by architect John Gries about 1860. Its plan is similar to the Farmers and Mechanics Bank. Because these banks were not located in Independence National Historical Park, they were spared demolition in the 1950s. The banking space now serves as the offices of DPK&A Architects.

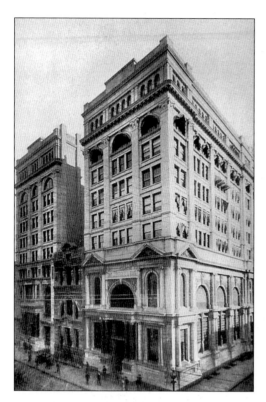

Seen here in 1899, the Drexel Building, at the southeast corner of Fifth and Chestnut Streets, was home to the Philadelphia Stock Exchange and the Drexel Bank, founded by Anthony J. Drexel. In 1885, it was originally built only two stories high, up to the second-floor cornice line. Later, the Wilson Brothers added seven more floors. The building overlooked both Independence Hall and the Old Customs House.

Sandwiched between two wings of the Drexel Building was the Independence National Bank, at 430 Chestnut Street. Designed by the Wilson Brothers in the late 1880s, its heavy, carved-granite façade looked more like a Victorian overmantel of the period. The bank and the Drexel Building were torn down in the 1950s, a period during Independence National Historical Park's stewardship that local architectural historians termed the "Reign of Terror."

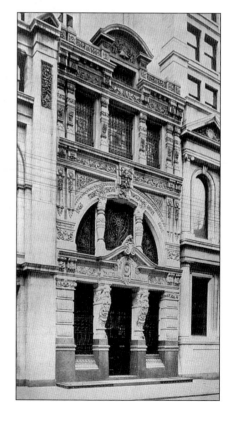

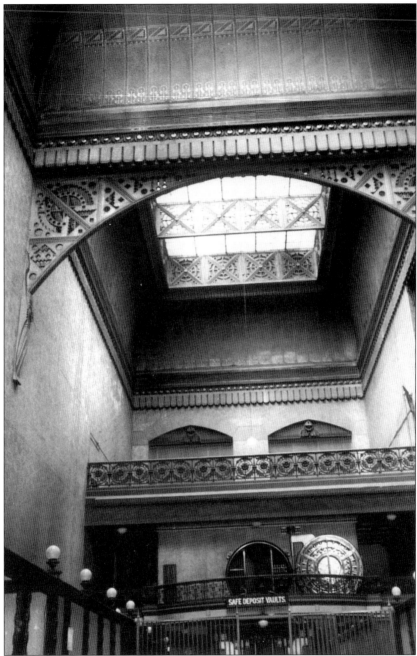

In 1959, when the author was an architectural student, he took this photograph of the Provident Life and Trust Bank, at 409 Chestnut Street, as the building was in the process of being demolished. The monumental banking space was lighted by a huge central skylight supported on decorative iron trusses. The walls were covered with decorative tiles; every architectural detail was designed by Frank Furness. In the 1950s, Frank Furness's work was still considered by many as an aberration. It was not until the restoration the Pennsylvania Academy of Fine Arts in 1976 that his architectural genius was fully recognized. However, by then all of his works located in the Independence National Historical Park area had been demolished.

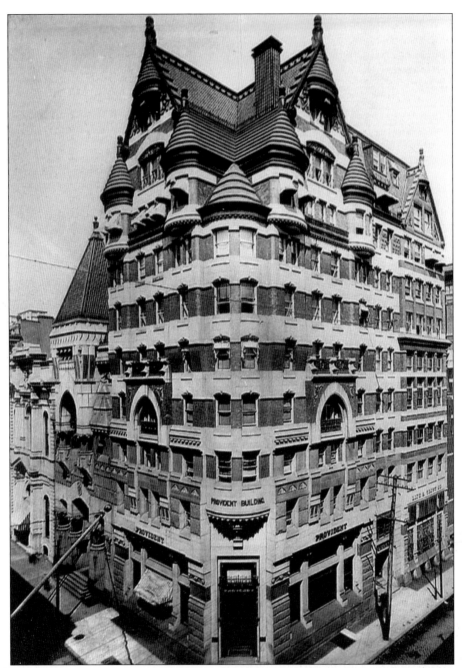

In the late 1880s, the Provident Life and Trust Company decided to build a new office building at the northeast corner of Fourth and Chestnut Streets, next to its High Gothic–style bank at 409 Chestnut designed by architect Frank Furness. A competition was held and won by architects Furness and Evans and Company. In 1890, the building was completed in a design intended to complement the neighboring bank building. The 10-story structure had hooded roof gables similar to those on the Manhattan Building, designed by architect Thomas P. Lonsdale. The office building was demolished in 1945. The 1876 bank building was considered one of Furness's best works; however, in 1959 it too was demolished.

The R. Wood Building, shown here, and the Brown Brothers Building once faced each other across the intersection of Fourth and Chestnut Streets and across from the Provident Life and Trust Company. All three buildings are no longer standing. Richard Wood employed architect Addison Hutton to design a "modern building" on the southwest corner with large windows for natural light at a time when electric lighting was still not reliable.

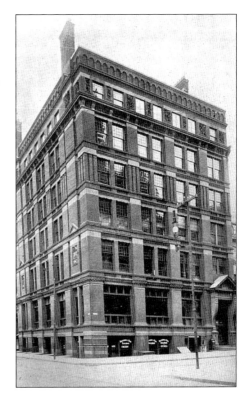

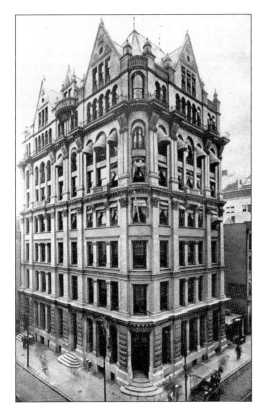

The southeast corner at Fourth and Chestnut Streets was the headquarters for Brown Brothers and Company, an investment banking firm founded in 1798. The building was constructed around 1889 and was designed by architect Theopholis P. Chandler in a mix of styles typical of his work.

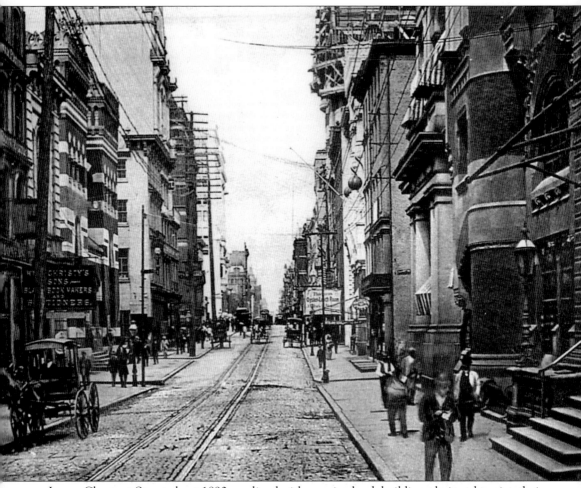

Lower Chestnut Street about 1890 was lined with massive bank buildings designed to give their depositors a sense of security. This view, looking west on Chestnut Street from Third, shows Frank Furness's Guarantee Trust and Safe Deposit Company's polychrome exterior on the left. On the right is another Furness design, the National Bank of the Republic. A few doors to the west is the Hewitt Brothers Fidelity Insurance Trust and Safe Deposit Company, with two granite globes overhanging the sidewalk. At Fourth Street, scaffolding surrounds the top floors of Furness's Provident Life and Trust Bank building.

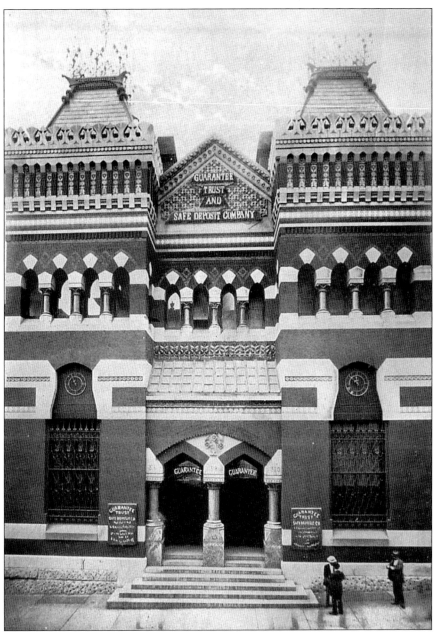

In 1873, Louis Sullivan, who would become a great architect, worked in Frank Furness's office as draftsman on the design of the Guarantee Trust and Safe Deposit Company building. Unfortunately for Furness and his draftsman, it was the same year Jay Cooke and Company suddenly closed its doors, causing a huge bank panic and curtailing future bank projects. Seen here in 1899, Guarantee Trust stood at 321 Chestnut Street and bordered the narrow walkway leading to Carpenters' Hall. Its mass and robust style overshadowed the neighboring hall. Furness's three-part design was similar to his concept for the Pennsylvania Academy of Fine Arts. By the 1950s, the building was surrounded by parking lots, its polychrome exterior black with soot, and its elaborate iron weathervane, cresting, and clocks gone. To reduce the potential fire hazard to nearby Carpenters' Hall, the bank was demolished in 1956.

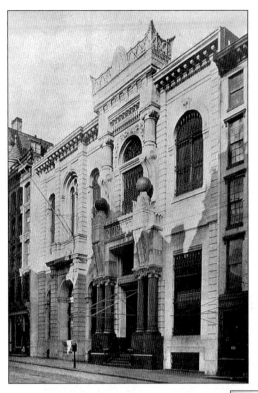

The Fidelity Insurance Trust and Safe Deposit Company building, at 327–331 Chestnut Street, was built around 1889 and designed by the Hewitt Brothers. George Hewitt worked for architect Frank Furness, and the Hewitts' design, with its top-heavy massive entrance, is reminiscent of Furness's 1876 design for the Provident Life and Trust Bank. The Hewitts chose to use classical Ionic columns at the entrance instead of the compressed columns in Furness's unique design.

Since being chartered in 1782 by financier Robert Morris, the Bank of North America had occupied the same site at 307 Chestnut Street, marking the beginning of Bank Row. In 1893, architects James Windrim and Sons designed this classically inspired building. Visible off to the left is Frank Furness's picturesque National Bank of the Republic, likely his wildest aberration. Both buildings were demolished in 1952.

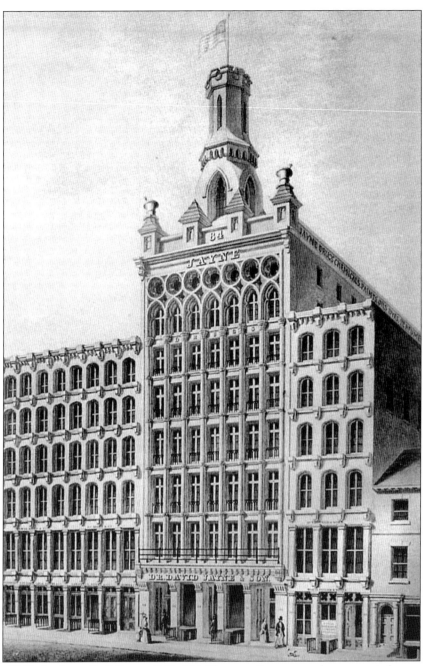

Built in 1849, the Jayne Building, at 242–244 Chestnut Street, was the country's first prototype skyscraper. Made of granite, it stood 10 stories high until a fire destroyed the tower in 1872. Thomas U. Walter finished the design of the building for Dr. David Jayne, a maker of patent medicines, when the original architect, William L. Johnson, died during its construction. Walter designed the west addition, also built of granite, in 1851. The building's style accents its verticality, ending at the top with windows reminiscent of the Doge's Palace in Venice. The Jayne Building was wantonly demolished in 1956, another loss due to the city's obsession with the Colonial style during the 1950s.

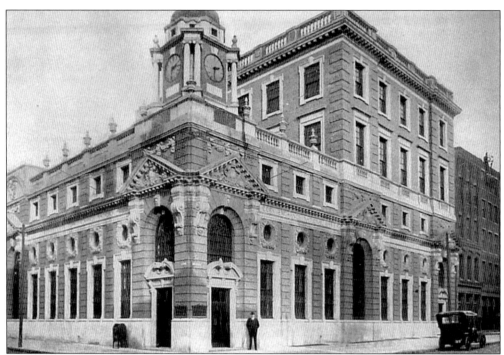

Architects Newman, Woodman, and Harris returned to Society Hill's Georgian heritage with their 1901 Edwardian Georgian design for the Corn Exchange National Bank and Trust Company building, at the southwest corner of Second and Chestnut. The building still stands and is now a restaurant.

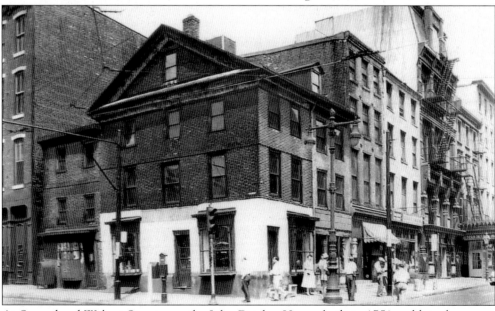

At Second and Walnut Streets was the John Drinker House, built in 1751 and later known as the Krider Gun Shop from 1856 to 1897. When this 1953 photograph was taken, the house had been greatly altered. The proprietors of the Old Bookbinders Restaurant, established in 1865 and seen on the extreme right, demolished the 1751 house in 1955 and erected a replica of it as part of the restaurant's expansion. (Courtesy Independence National Historical Park.)

Four
WALNUT STREET AND INSURANCE ROW

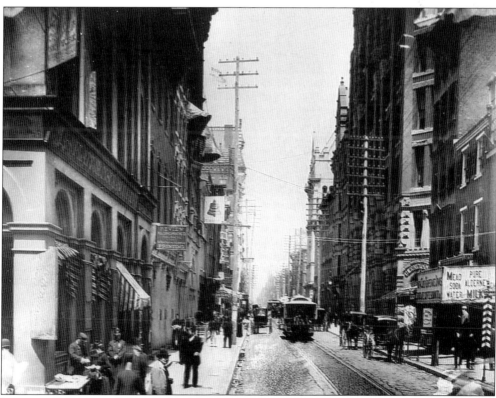

Insurance Row extended beyond Walnut Street into the major cross of streets, as seen in this 1893 northward view from Walnut up South Fourth. Horse-drawn trolleys traverse Fourth Street because the electrification of Philadelphia's trolley system did not come until 1898. The large structure on the right was the Bullitt Building. (Courtesy Dr. W. R. Duntun Collection, Independence National Historical Park.)

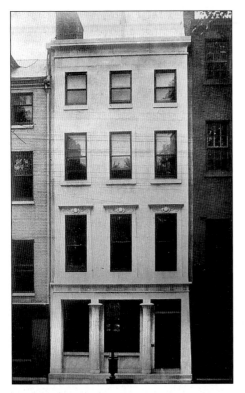

Insurance Row ran for four blocks along Walnut Street from Second to Sixth Streets. Along this stretch stood Philadelphia's most extravagant Victorian office buildings designed by the foremost architects of the day. Architect John Haviland used the Egyptian Revival style for the façade of the Pennsylvania Fire Insurance Company building, constructed around 1829. This 1899 photograph shows Haviland's original white marble building at 510 Walnut Street.

In 1902, architect Theopholis Chandler enlarged the Pennsylvania Fire Insurance Company with a matching addition, making the building six bays wide, as shown in this 1902 photograph. The building was demolished around 1974, but the façade was preserved by a "façadectomy." It is now used as a screen to the entrance courtyard for Penn Mutual's modern 21-story office building.

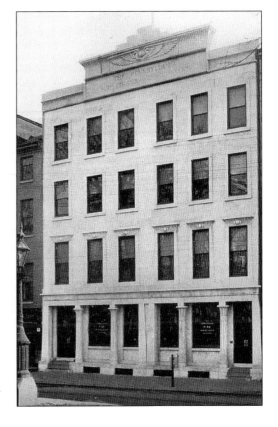

One of Philadelphia's most extravagant Victorian office buildings was the Imperial Building, at 411–413 Walnut Street, designed by architect Amos J. Boydon. He designed this building in a late Queen Anne style with details often seen in residential design. It was demolished in the 1920s. Visible on the right is part of the neighboring Fire Association Building, at 407 Walnut Street, built in 1890 and designed by architects Hazelhurst and Huckel.

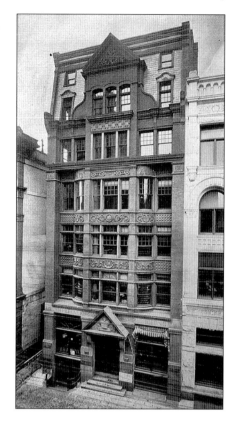

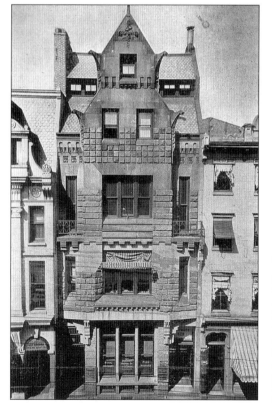

With only 22 feet of frontage, the façade of the Reliance Insurance Company, at 429 Walnut Street, made a strong statement. It was designed about 1882 by architects Furness and Evans in a picturesque Queen Anne style, complete with gargoyles on the upper façade. One of the bank's directors was Effingham B. Morris, owner of the Reynolds Morris mansion. The insurance building was demolished in 1960.

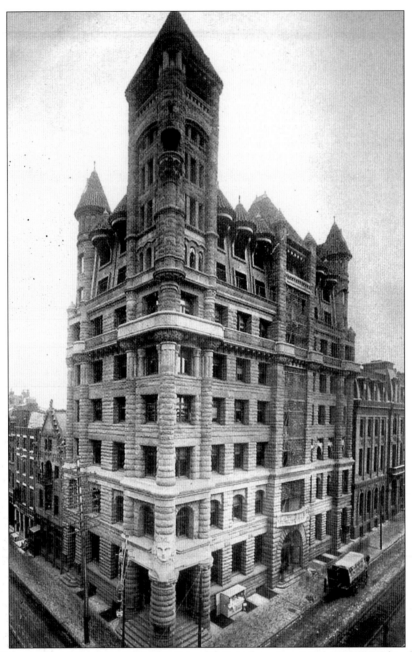

Certainly one of the most exuberant architectural designs for an insurance company's headquarters was the American Life Insurance Company building, better known as the Manhattan Building. It stood at the southeast corner of Fourth and Walnut Streets until demolition in 1961. Built in 1888, the Manhattan Building was designed by architect Thomas P. Lonsdale, who also worked on the Baptist Temple on North Broad Street. One of Philadelphia's early skyscrapers, the Manhattan Building was constructed in a picturesque Romanesque style with rounded stone bearing columns, giving it the appearance of a drip sand castle. In this 1899 photograph, a central, open fire-escape shaft covered with a metal grill is visible on the Fourth Street elevation. The sculpted head of an American Indian overlooks the corner entrance.

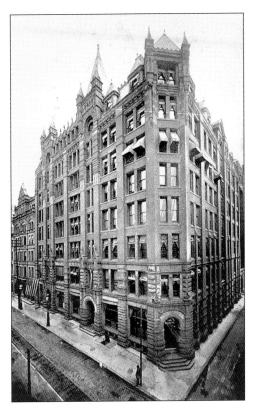

The massive Bullitt Building, located at 131–145 South Fourth Street, was designed in 1886 by the Hewitt Brothers. That same year, the architects also designed a massive new residence for its owner, John Christian Bullitt, at 125 South Twenty-Second Street. The Hewitts extended out the Bullitt Building's central entrance bay and created a spiked roof profile, a design popular in the 1880s.

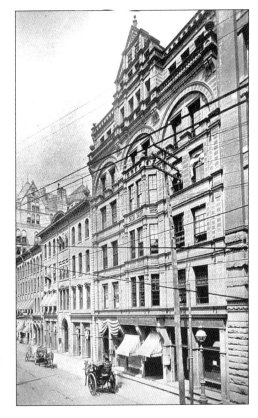

Adjacent to the Bullitt Building, at 119 South Fourth Street, was the Forrest Estate Building, built in 1884 and designed by architect Addison Hutton. The Forrest Building stood very close to the west side of Carpenters' Hall, and like the Bullitt Building and the Guarantee Trust and Safe Deposit Company on Chestnut Street, it was considered too dangerous a fire hazard and was subsequently demolished.

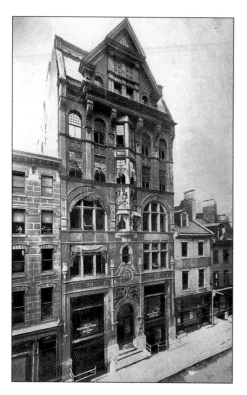

At 136–138 South Fourth Street, towering over its 18th-century neighbors, was the Insurance Company of the State of Pennsylvania Building. It was designed in the Queen Anne style by a young architect named J. Roney Williamson. Williamson's career was cut short when he died at the age of 45.

Built in 1880, the Insurance Company of North America Building, at 232 Walnut Street, was also designed in the Queen Anne style with a heavy English accent. Its official architect was the Boston firm of Cabot and Chandler, who engaged Philadelphia architect Amos Boydon to execute the project. The design looks like Boydon's work, whose style was in the current fashion of that day.

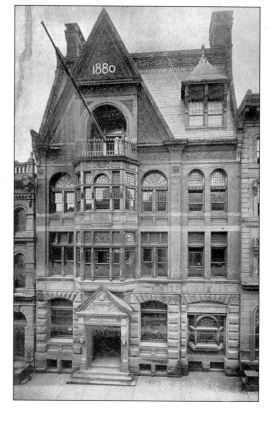

Five

OLD CITY NORTH OF CHESTNUT STREET

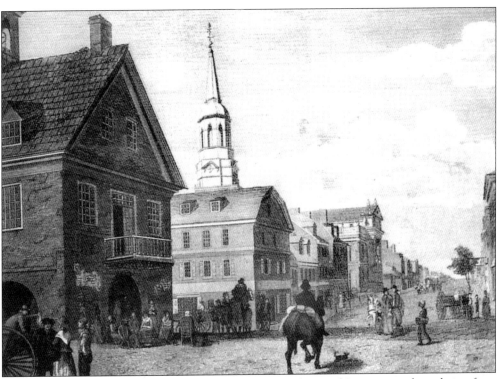

In 1800, William Russell Birch published this engraving of Second Street, a northward view from Market (then called High Street) showing the area of Old City. It was a place of commerce and trade with many fine buildings. The tallest structure in Colonial Philadelphia was the steeple of Christ Church, shown here. In the center of High Street was the town hall, built in 1707, with market sheds extending to Fourth Street. From its balcony, governors and mayors delivered their inaugural addresses, and Methodist preacher George Whitefield spoke to thousands. The market sheds were demolished in 1837.

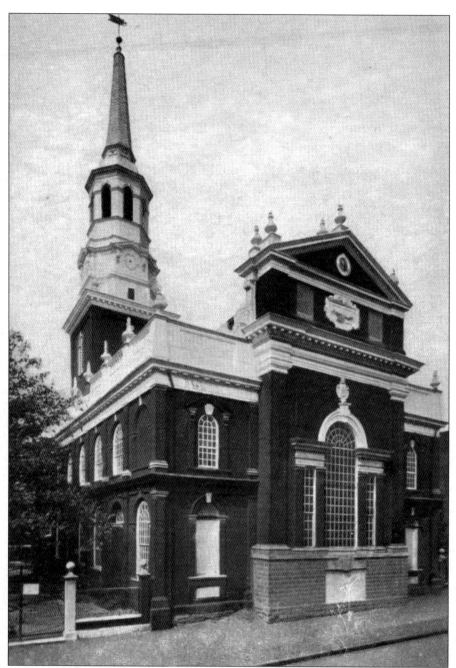

Christ Church, the oldest Anglican congregation in Philadelphia, still stands on Second Street just north of Market. It was built in three sections: the western half in 1727; the eastern half, including the great Palladian window facing Second Street, in 1735; and the steeple by Robert Smith in 1754. At the time of the American Revolution, Christ Church's congregation included some of the most important and affluent citizens of Philadelphia, among them George Washington, Thomas Jefferson, Benjamin Franklin, and Betsy Ross. Throughout the 19th century and until recently, the church was surrounded by factories and workshops. This has dramatically changed with the current interest in the restoration of Old City.

North of Market were the small streets and courts holding the modest homes of craftsmen and artisans. They stood in contrast to the larger homes of the wealthy merchants of Society Hill. Just north of Christ Church is Elfreth's Alley. Built around 1725, it is the country's oldest residential street with houses still standing on both sides. Once home to craftsmen, printers, and carpenters, Elfreth's Alley is seen here about 1915.

Patrons entered the Old Black Horse Inn through an archway from Second Street near Callowhill. At night, the great doors to the archway were shut. Inside was an ancient inn-yard, which was a long, rough cobblestone courtyard with overhanging balconies, a feature common in 19th-century London and English provincial towns. Here, wagons and horses were stabled for the nearby places of commerce. This photograph was taken around 1920.

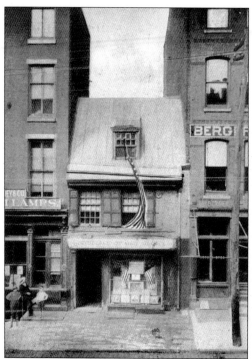

At 239 Arch Street is the home of Betsy Ross, who is credited with making the first American flag. Betsy lived in the c. 1740 house and ran an upholstery business there between the years of 1773 and 1786. In 1898, when this photograph was taken, two million Americans donated dimes to restore the battered house into a national shrine.

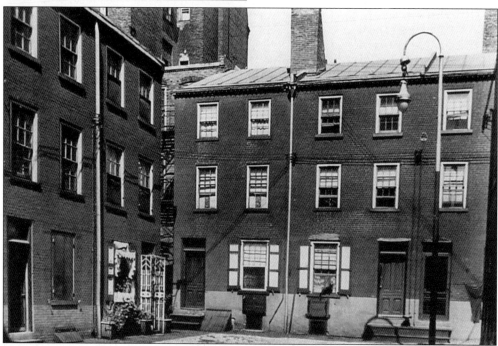

Between 321 and 323 Arch Street is Loxley Court. No. 8, the middle building in the back row, was the second meeting place of the Society of Methodists. The upper floors lodged the famous preacher George Whitefield, and meetings were held on the lower floors between 1767 and 1769. The key to Benjamin Loxley's house at No. 2 was used by Benjamin Franklin for his kite-flying lightning experiment.

In this Quaker city, the most Quaker street is Arch, its 300 block the home of the Friends Meeting House—the oldest still in use in Philadelphia and the largest in world. The Philadelphia Yearly Meeting is held here. The meetinghouse was built in 1804 and designed by Owen Biddle in a Quaker Plain style. The west wing was added in 1811. By the 19th century, Arch Street had become lined with factories and warehouses, yet the meetinghouse remained, as seen in the above 1920 photograph. The below 1905 postcard shows a crowd of worshipers in front of the Friends Meeting House. Several elderly Quaker ladies can be seen dressed in the old garb and bonnets, although the postcard's sender commented, "You seldom see the plain dress on the streets of Philadelphia anymore."

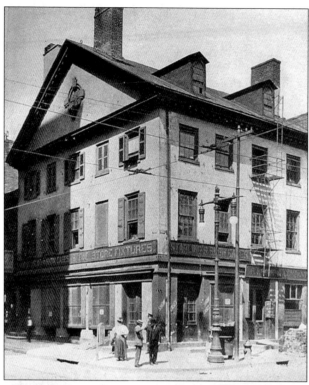

Facing the Friends Burial Ground, at the northeast corner of Fourth and Arch Streets, was the home of Rev. William Smith, the first provost of the University of Pennsylvania. The university built the house for the provost in 1774, and Smith lived there until 1793, when his successor moved in. It became a boardinghouse in 1844 and appears here in 1912.

The Christ Church Burial Ground occupies the southeast corner at Fifth and Arch Streets. A grated opening in the cemetery's Arch Street wall was left so that those passing by could see the graves of Benjamin and Deborah Franklin. In 1790, when Franklin died, 20,000 Philadelphians followed the cortege to his grave. Rev. William Smith, provost of the University of Pennsylvania, gave the eulogy at Christ Church.

Occupying its 412 Arch Street site since 1874, Shoyer's Restaurant was known for its excellent seafood and proclaimed itself "Philadelphia's Oldest Restaurant" on this 1940s postcard. Shoyer's no longer exits. Old Original Bookbinders, at Second and Walnut Streets, which reopened in 2005, now claims the title of oldest restaurant.

In 1902, the Curtis Publication Company was located at 425 Arch Street. Built in 1898, the structure was home to the *Ladies' Home Journal* and the *Saturday Evening Post*. In 1912, Curtis Publications moved to new headquarters in a massive, modern building in Independence Square.

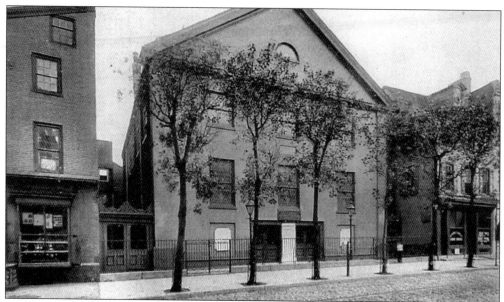

Seen above in 1910, Old St. George's is the oldest Methodist church in the country. It stands today at 235 North Fourth Street, in a building likely designed for a German Calvinist congregation by Robert Smith in 1763–1769. It became a Methodist church, and in 1784, former slave Richard Allen became the first African American to be licensed to preach from St. George's. He went on to become the first bishop of the African Methodist Episcopal Church and subsequently founded the Bethel Church. In the 1920s, St. George's stood in the path of the proposed Delaware River Bridge and was scheduled for demolition. Because St. George's won a lawsuit forcing the bridge to be moved 14 feet to the south, it received the reputation as "the church that moved a bridge." Fourth Street had to be depressed to the church's basement level to clear the bridge, as shown below.

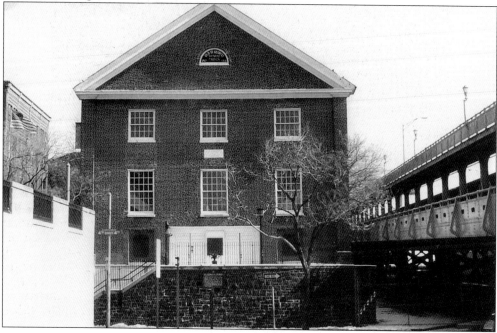

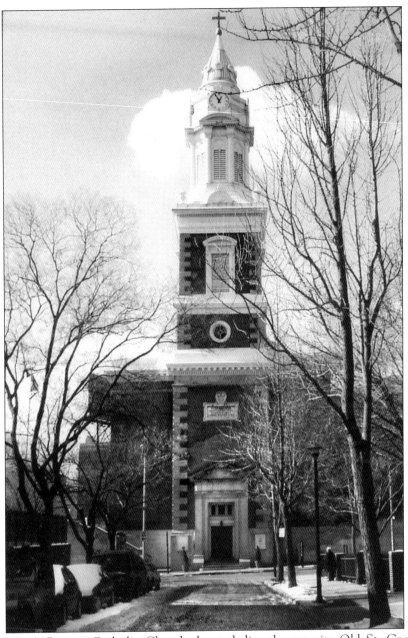

St. Augustine's Roman Catholic Church, located directly opposite Old St. George's on North Fourth Street, was the other church spared demolition for the Delaware River Bridge. The first church on this site, built in 1824, was burned during the anti-Catholic riots of 1844. Napoleon LeBrun, architect for the Academy of Music, designed this church on the foundations of the burned church. The rebuilt St. Augustine's was consecrated in 1848. In the 1920s, a huge bridge plaza was proposed for the east side of Franklin Square. Three historic churches—Old St. George's Methodist, St. Augustine's, and St. John's Evangelical Lutheran—were in the proposed right-of-way of the Delaware River Bridge. Unfortunately, St. John's, designed by engineer Frederick Graff in 1818, was not spared and was demolished in 1924. Its congregation relocated to West Philadelphia.

Old City north of Market Street was heavily industrialized in 1902. One of the finest and most unusual Old City industrial buildings was the factory of Horace T. Potts and Company, a fabricator of iron and steel. Located at 316–320 North Third Street, it was designed by noted architect Frank Miles Day in a Venetian Gothic style in 1896. The building unfortunately burned down in 1976.

At the dawn of the 20th century, Philadelphia was a major center for the manufacture of leather goods and shoes. In 1893, architects Hazelhurst and Huckel designed this factory for C. F. Rumpp and Sons, a maker of fine leather goods and pocketbooks. Built of blue Indiana limestone, the building at 114–130 North Fifth Street looked more like an office building than a factory. It was demolished in 1965.

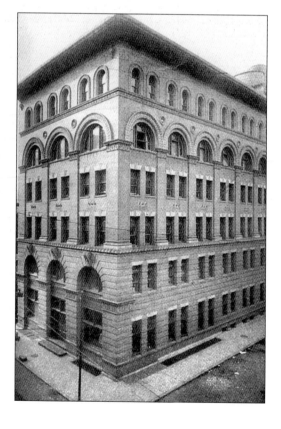

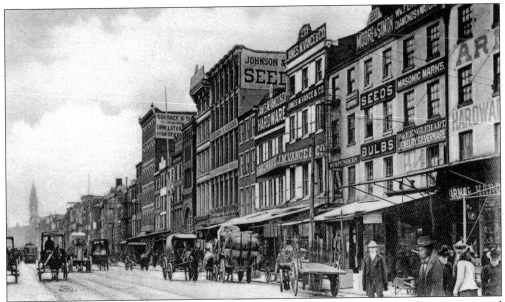

Lower Market Street, as seen here in 1904, was home to seed companies, hardware stores, and ship chandlers—all businesses connected with the nearby docks and farmers' produce market. Some buildings dated from the 1850s, such as the Johnson and Stokes Seed Company, at 217 Market Street (in the middle block), built in 1857. A later addition to the block was the Schrack and Sherwood Upholsters six-story factory, at 233–235 Market, constructed in 1898.

Philadelphia was once called the "Workshop of the World." Aside from the big factories and warehouses, many small workshops were located above the street-level stores. This 1910 postcard from the Charles Lentz and Sons orthopedic shoe factory, at 18–20 North Eleventh Street, depicts the daily working conditions of the craftsmen, most likely recent immigrants, as they stood long hours at their benches making shoes.

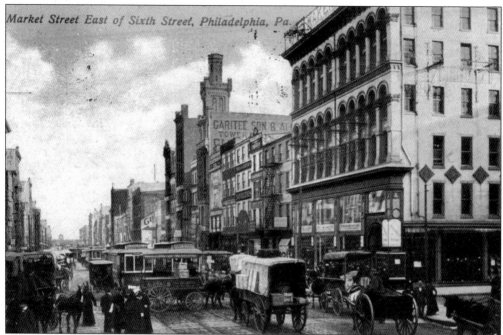

On April 8, 1861, at the southeast corner of Sixth and Market Streets, Wanamaker and Brown opened Oak Hall, a men's and boys' clothing store, on the first floor of what was called McNeilles Folly because it was six stories high. Oak Hall, shown above, revolutionized the clothing business by offering fixed prices on clothing and giving back money for returned merchandise. The first day's intake was $24.67—$24 of which John Wanamaker spent on advertising; 67¢ was saved for the next day's change. Wanamaker would become a merchandising giant. In the middle of the block was the Gothic Bennett's Tower Hall, designed by architect Samuel Sloan in 1853. Below is a 1904 postcard of the southwest corner of Seventh and Market Streets. The Penn National Bank occupied the site where Thomas Jefferson penned the Declaration of Independence. Today the reconstructed Graff House stands on that corner.

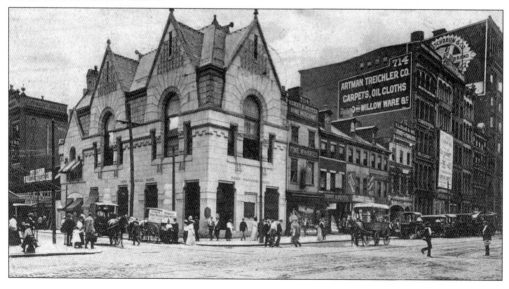

The Lit Brothers and Strawbridge and Clothier department stores are decked out for the 1908 Elks Convention. The Lit Brothers building was designed by architects Collins and Autenreith. Constructed in pieces over a period of years from 1859 to 1907, it is an example of Italianate-style cast-iron architecture. Lit Brothers closed in 1977, but the building's proposed demolition was stopped by public outcry. It now serves as offices.

Cast-iron construction allowed large windows, thus giving buildings maximum natural light and ventilation, as seen in this 1898 photograph of Huey and Christ Distillers store, at 1209 Market Street. To the right, at No. 1207, was architect Frank Furness's store design for Francis Fassit, the uncle of Furness's wife. Built in 1881, the cast-iron and stone façade is decorated with Furness's signature sunflower motif. Both buildings no longer stand.

This 1960s photograph of Old City and Society Hill shows the extensive area cleared for Independence Mall, running from Fifth to Seventh Streets and from Chestnut Street to Franklin Square. The large street running to the Delaware River is Market Street. Society Hill Towers is visible in the upper right. As early as 1933, architect Paul P. Cret proposed an extension to Independence Square, a modest-sized park, one block long, extending north to Market Street. His design included a forecourt in scale with Independence Hall, which removed the fire hazard presented by the warehouses. In 1944, Roy Larson of the firm of Harbeson, Hough, Livingston, and Larson presented a scheme extending the Mall north to Franklin Square, and as this 1969 aerial photograph shows, his bold plan was eventually achieved. (Courtesy Philadelphia City Planning Commission.)

Six
SOCIETY RETURNS TO SOCIETY HILL

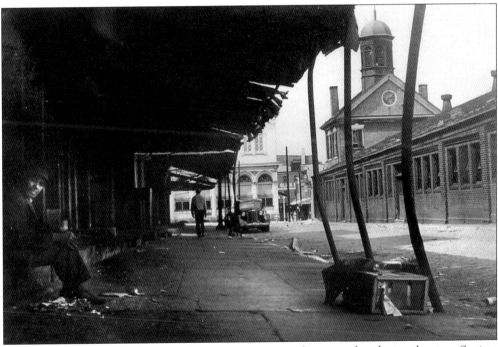

It took men and women of vision and courage to see past the years of neglect and restore Society Hill to the point where "society" would again want to live there. This late-1930s view reveals the shambles at Second Street, looking south toward Pine Street. The Head House is visible at the south end of the market sheds. Second Street appears very shabby and dirty. Here, the neglected historic buildings have become factories and warehouses, and there is no lack of cheap bars and flophouses on this street of broken dreams. As one strolls down Second Street today, past its up-scale shops and restaurants, it is hard to believe that the area once looked like this. (Courtesy Nancy Widerman.)

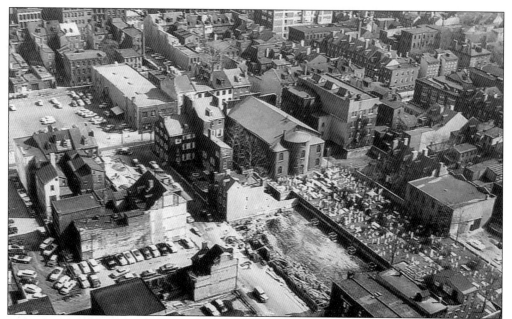

This 1950s bird's-eye view of Society Hill was taken from the Penn Mutual Building. Old St. Mary's Church and graveyard are visible at 244 South Fourth Street. The fabric of Society Hill was tattered, and yet hundreds of historical houses were still standing, many in poor condition but worth restoring. The planning decision to save these historic houses has proven right. (Courtesy Independence National Historical Park.)

In the late 1950s, demolition began on buildings considered either intrusions or fire hazards to Independence National Historical Park's buildings. This photograph shows the demolition of the Drexel Building, located next to the Old Customs House in the 400 block of Chestnut Street. The 1950s glass-box office building to the left was constructed outside the historical park's boundaries. (Courtesy Independence National Historical Park.)

This late-1950s photograph shows, from left to right, Mayor Richardson Dilworth, Harry Batten of the N. W. Ayers Company, local ward leader Arnold Bloomberg, and Reverend Harding of Christ Church. These men are examining Edmund Bacon's proposed master plan and model for Society Hill's renewal. The model includes a huge cloverleaf intersection at Second and Lombard Streets for a proposed cross-town expressway. (Courtesy Nancy Widerman.)

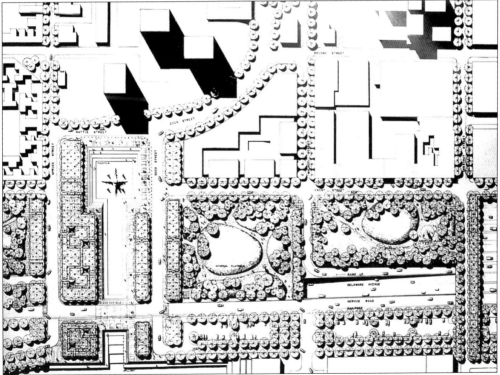

The suggested 1968 master plan for Society Hill by Edmund Bacon still involved the formerly proposed Lombard Street Cross-town Expressway (not shown), Penn's Landing, and Society Hill Towers. Note the extensive landscaped cover planned for the depressed Interstate 95 expressway. (Courtesy Philadelphia City Planning Commission.)

In the 18th century, many palatial dwellings belonging to wealthy merchants and importers were built close to their wharves and counting houses. A fine example of a merchant's Federal town house is the John Clement Stocker House, at 404 South Front Street. Stocker was a wealthy merchant banker and city alderman who built this large house, with its abundance of finely carved ornament, between 1791 and 1795. In this c. 1910 photograph, the house has been altered into a store; 26 years later it would become a warehouse. To the right of the Stocker House, at 402 South Front Street, was the house of much-revered Bishop William White of Christ and St. Peter's Churches. He lived at this address until he was elevated to the episcopate. Bishop White also served as chaplain to the Continental Congress. (Courtesy Charles Peterson Collection.)

In the 1970s, the John Clement Stocker House was the sole survivor on the block; the boarded-up house was standing alone, surrounded by rubble. In 1978, it was restored. The house is symbolic of Society Hill's rebirth. It even outlasted the modern-designed Head House Square Development, which was built next door.

The loading dock and dumpster of the intrusive Head House Square Development became the Stocker House's new neighbor in 1966. The building project, involving a series of glass boxes lacking in human scale with an obscure entrance on Second Street, had to be completely rehabilitated in 1973. A financial and architectural failure, the Head House Square Development was demolished, leaving a gaping hole on South Front Street for years. As of this writing, it still awaits redevelopment.

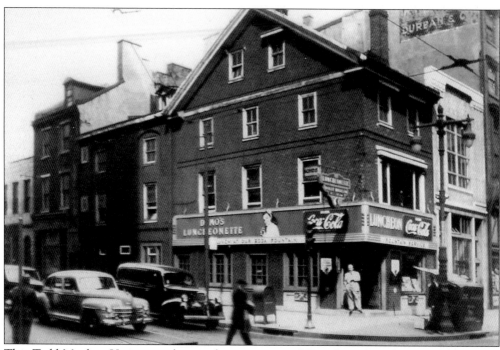

The Todd-Moylan House, at the northeast corner of Fourth and Walnut Streets, was a luncheonette when Charles Peterson took the above photograph in 1951. This had been the residence of John Todd Jr. and his wife, Dolley Payne Todd, from 1791 to 1793. John Todd died in 1793 in the yellow fever epidemic. In 1794, Dolley married young James Madison, who became president of the United States 15 years later. Revolutionary War general Stephen Moylan lived here from 1796 to 1807. The luncheonette served Dolley Madison Ice Cream and had a sign hanging over the front door with the ice-cream company's logo. However, it is doubtful that the patrons seen at the luncheonette's counter in the 1951 photograph below even knew that they were actually dining in Dolley Madison's house, as there was no marker on the building. (Courtesy Independence National Historical Park.)

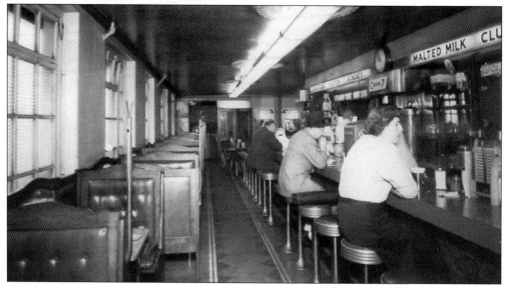

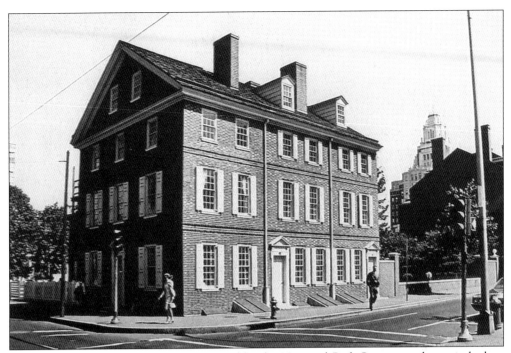

The Todd-Moylan House has been restored by the National Park Service to the period when the Todds occupied it. The front door is once again on Fourth Street and the rear garden has been restored. Independence National Historical Park has opened the house to the public. The adjoining town houses are reconstructions of the block, as it would have looked, based on historical research. (Courtesy Independence National Historical Park.)

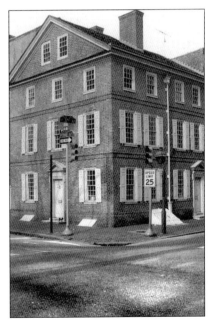

Another reconstruction is the Thaddeus Kosciosko National Memorial, dedicated to the memory of the much-revered Polish hero of the Revolutionary War. The house stands at the northwest corner of Third and Pine Streets and is open to the public. It was donated in early 1970 by Edward Piszeck, founder of Mrs. Paul's Frozen Foods. Note the close resemblance of the Kosciosko house's design to that of the Todd-Moylan House.

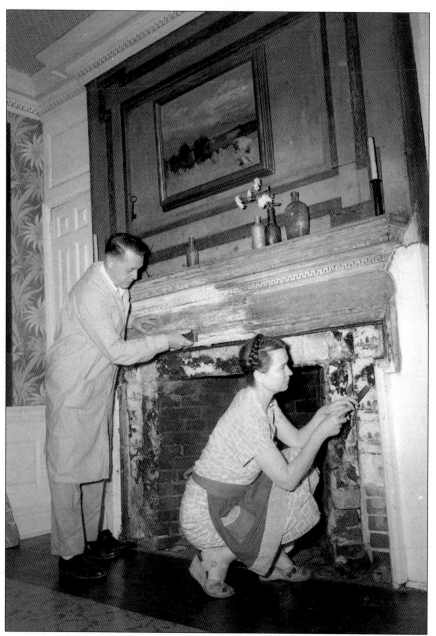

Not everyone hired private contractors to restore their homes; some chose to do the restoration work themselves. Earle and Beatrice Kirkbride were pioneers in the restoration of Society Hill. Earle was a renowned fine artist and illustrator, and his wife was an architectural historian for the Philadelphia Historical Commission. Here, they are shown doing the tedious handwork required to restore the 18th-century interior of their home, the historic Nathaniel Irish House, at 704 South Front Street. They removed 32 layers of wallpaper to discover the Colonial fireplace intact. The Kirkbrides also uncovered behind the same fireplace a rare 18th-century Tory fireback depicting King George unhorsing George Washington, with the American flag falling to the ground. The fireback is now in the Mercer Museum. (Courtesy Edward Kirkbride and Temple's Urban Archives.)

Shown here as a cheap boardinghouse in 1955, the Davis-Lenox House had been built by James Davis about 1758 at 217 Spruce Street. In 1959, prominent Philadelphian C. Jared Ingersol bought the house for $8,000. He is reported to have spent $80,000 in restoring the structure to its 1784 state, when it was the home of Maj. David Lenox, Revolutionary War hero and later American minister to Great Britain. (Courtesy Charles Peterson Collection.)

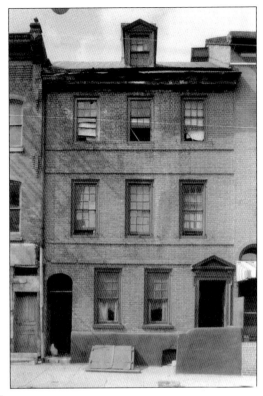

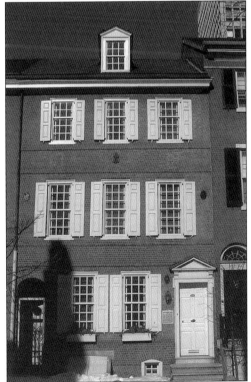

The Davis-Lenox House was beautifully restored by architect George B. Roberts and looks like this today. Due to Ingersol's prominence in Philadelphia society, his move to Society Hill sparked many others, such as Dr. F. Otto Haas, to do the same. Henry Watts, president of the New York Stock Exchange, built a new Georgian-style house next door, at 219 Spruce Street. More than anyone, C. Jared Ingersol is credited with bringing society back to Society Hill.

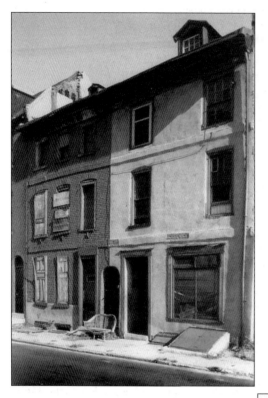

The John Palmer House, at 117 Lombard Street, and the neighboring Joseph Wharton House (on the left), at 119 Lombard Street, were certified historical in 1957. Charles Peterson photographed them in 1962. Both houses were built in 1743, likely by bricklayer John Palmer. They were saved during Mayor Dilworth's tenure in City Hall.

The Palmer House was carefully restored around 1966. The Wharton House was restored in the early 1970s by architect Duncan Buell, who had to keep the house's front wall, held in place by three star bolts, from falling onto the sidewalk, as seen in the pre-restoration image above. This type of restoration is costly, but the result is priceless.

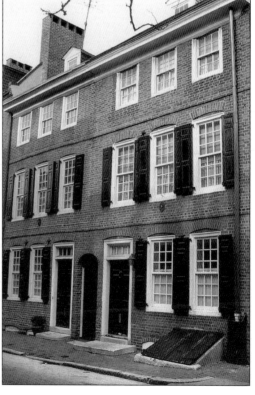

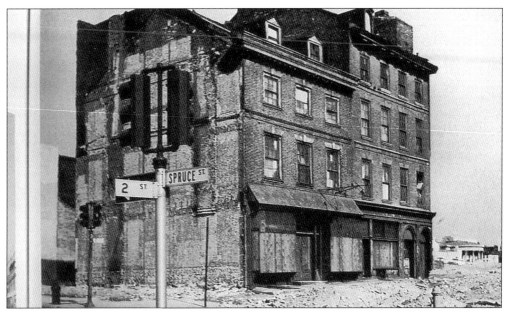

Capt. James Abercrombie was a wealthy Scottish sea captain. In 1769, he built one of the largest Georgian town houses in Colonial Philadelphia, five stories high. Located on the high ground at 268–270 South Second Street, the house provided the captain with a commanding view of the port from its upper floors. Its immediate neighbor to the south is the Samuel Neave House, a fine Georgian building constructed about 1758 for a prominent Philadelphia merchant. By 1857, both homes had become stores as Society Hill declined. The above photograph was taken in the 1960s, when both were surrounded by the rubble of redevelopment. In 1967, both houses were restored (below). The Abercrombie House became the Perelman Antique Toy Museum and now stands at the base of the entrance court to Society Hill Towers. (Courtesy Charles Peterson Collection.)

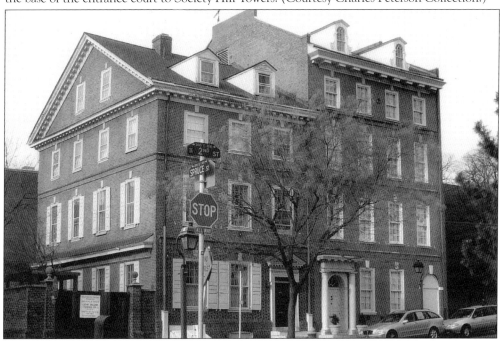

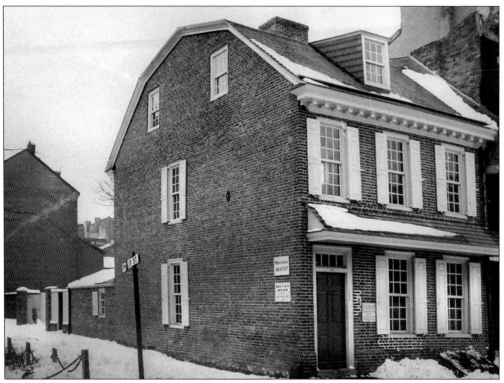

The Rhoads-Barclay House, at 217 Delancy Street, was one of the first important private restorations in Society Hill. The home of Dr. F. Otto Haas, the building was restored and an elegant Japanese garden was added to the rear. These actions encouraged citizens to renovate other nearby historic homes. Originally built for Samuel Rhoads, master builder and mayor of Philadelphia in 1774, the residence was restored in 1960 by Robert T. Trump. (Courtesy Robert T. Trump.)

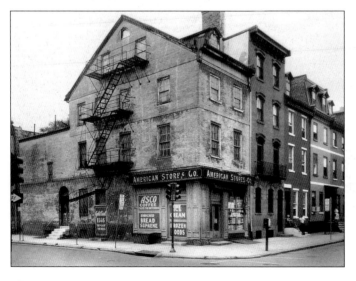

The Joseph Jefferson House at Sixth and Spruce Streets, shown here c. 1950, was renovated by architect Edwin Brumbaugh in 1969–1970. The rear ell was removed to make a garden. Brumbaugh restored the Jefferson House to its original appearance, as it had been designed by house carpenter Edward Bonsall in 1804. (Courtesy Charles Peterson Collection.)

This 1958 photograph shows the Benjamin Paschal House, at 129A Spruce Street, built in 1759. Next door to the right is the Man of Full Trouble Tavern, perhaps the only 18th-century tavern yet extant in the country. At the time they were photographed, both properties were near collapse, surrounded by tin sheds, and were choice candidates for demolition. (Courtesy Charles Peterson Collection.)

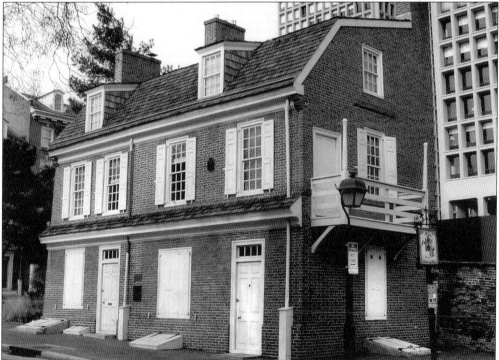

In 1965, the Knauer Foundation for Historic Preservation restored both properties and opened them to the public as a museum. Note the similarity of the restored buildings to the Rhoads-Barclay House (on opposite page). The Man of Full Trouble Tavern sign, seen to the right, was reproduced from a historical description in *Watson's Annuals*. It shows a man holding a parrot with a monkey on his shoulder and his wife on his arm.

The Reed House, at 518 South Front Street, was a sorry sight when Charles Peterson took this photograph in 1958. Part of a pair, the house was built in 1796–1798 and was converted to a store in 1918. It was a fine example of a rich merchant's town house, with a prime location near the docks and close to the shops and warehouses. (Courtesy Charles Peterson Collection.)

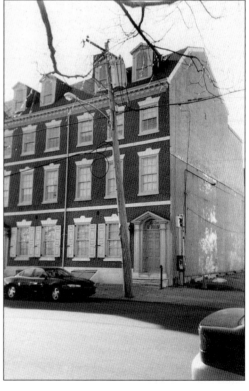

In 1979, the pair of houses were restored into offices and apartments by architects Zimmers Associates. They now overlook a park at the edge of Interstate 95 instead of facing warehouses, as they had in the 19th century. South Front Street is now lined with new and restored homes.

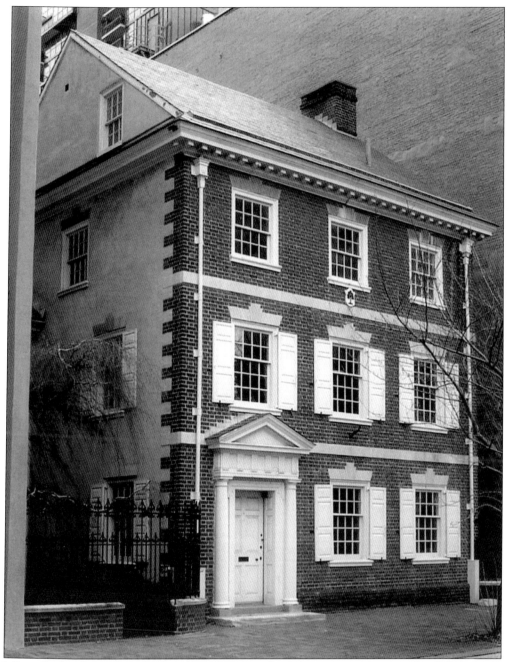

Mayor Richardson Dilworth's house stands next to the Athenaeum on the east side of Washington Square. It was built in the Georgian style by architect George Edwin Brumbaugh in 1957. The house's architecture and distinguished architect are not the only reason it is noteworthy. It stands as a strong commitment by one of Philadelphia's greatest mayors to the renewal of Society Hill and Washington Square, both tattered and crumbling in the 1950s. Mayor Dilworth's house is a monument to his confidence in the city's future, leading the way to the eventual restoration of a neglected historic neighborhood. As of this writing, the Dilworth House is in danger of being demolished for a new high-rise condominium.

ACKNOWLEDGMENTS

A few weeks after the death of historian Charles E. Peterson, I met with his longtime secretary, Hilda Sanchez, who was busy packing his extensive archives to be sent to the University of Maryland. I told her that I was about to embark on the writing of a book on Society Hill and Old City and asked for permission to copy some Society Hill photographs Charles took in the late 1950s. After some close scrutiny, she agreed to let me photograph some of his archival images for use in the book. I particularly wish to thank Hilda Sanchez for her kindness, and for making it possible to include Charles Peterson's photographs in the book.

In addition, I wish to thank the following individuals and institutions who generously lent images: Dell Connor, director of the Powel House; Andrea C. Ashby Leraris of the Independence National Historical Park; Old York Road Historical Society; Philadelphia City Planning Commission; Robert T. Trump; Nancy Widerman; and Howard Watson. Enormous sources of historical information were the Athenaeum of Philadelphia's Web site entitled *Philadelphia Architects and Buildings* (PAB), and Richard Webster's superb book *Philadelphia Preserved*. I am grateful to historians Penny Batcheler and Harry Boonin, author of *The Jewish Quarter of Philadelphia*, for their assistance. Well-deserved thanks are also due to William Jenoves, who did the photography, and David Rowland, president of the Old York Road Historical Society, who read the text and provided other assistance.

Charles E. Peterson was a preservationist, historian, and author. He died in September 2004 at the age of 98. Mr. Peterson had resided in Society Hill since 1954, and "is credited with shaping historical preservation in Philadelphia and around the country." Photographs from his archives reproduced in this book show his early concern for documenting and saving endangered historical structures in Society Hill. Fortunately, Charles Peterson lived long enough to see Society Hill go from a "has-been neighborhood" to an area of beautifully restored historic homes. (Photograph by J. Kyle Keener, July 1994; Courtesy *Philadelphia Inquirer*.)